DEGAS

The life and work of the artist illustrated with 80 colour plates

SANDRA ORIENTI

THAMES AND HUDSON

Translated from the Italian by Rosalind Hawkes

This edition © 1969 Thames and Hudson, 30–34 Bloomsbury Street, London WC1
Copyright © 1969 by Sadea Editore, Firenze
Reprinted 1984

Printed in Italy

Life

The de Gas family (the painter used this form of his surname until 1870, when he began signing himself in the form generally known) was Breton in origin; the artist's grandfather René-Hilaire de Gas had left France for Naples during the Revolution. Pierre-Auguste-Hyacinthe de Gas, the painter's father, moved to Paris to open a branch of the family bank, and married Marie-Célestine Musson, of a Creole family.

Edgar-Hilaire-Germain de Gas was born in Paris on 19 July 1834. As a child, his father took him to see the works of the masters at the Louvre, and he later became acquainted with some of the best-known collectors and connoisseurs of his time. In 1845 he went to the Lycée Louis-le-Grand, where he met Henri Rouart, who was to remain a close friend all his life. In 1847, his mother died.

In 1852 Edgar Degas took his *baccalauréat*, left school, and began to study law. But although his father wanted a safe and traditional legal career for his son, he was sympathetic enough to his artistic interests to give him a studio in the family apartment in the Rue Mondovi; he allowed him to study drawing with Louis Lamothe, a pupil of Ingres, to work in the studio of the painter Barrias, and to spend time copying paintings and prints by Dürer, Mantegna, Goya and Rembrandt in the Louvre. By 1853 Edgar was devoting all his attention to art.

In 1855 he met Ingres, and entered the Ecole des Beaux-Arts, where he made friends with Tourny, Léon Bonnat, Ricard and Henri Fantin-Latour. But the pedantic narrowness of the teaching repelled him, and he left after a year.

In 1856-7 he paid a long visit to Italy, staying with various relatives and making an intensive study of Renaissance painting. He travelled through the Abruzzi, Umbria, Latium, Tuscany and Campania, and stopped in particular in Naples, Rome, Orvieto and Florence, where, perhaps, he began sketching studies for the well-known collective portrait of

his aunt Laura de Gas, her husband Baron Bellelli, and their daughters (*pls 4-5*).

In Paris, in 1858, his friend the engraver Félix Bracquemond showed him several reproductions of works by Utamaro, and Degas began to take an interest in Japanese art. He returned to Rome in the same year, spending much time at the Villa Medici. Then he visited Florence, passing through Viterbo, Orvieto (where he studied the work of Luca Signorelli), Perugia, and Assisi. He returned to Paris in April 1859.

His friendship with Manet dated from 1862; they met in the Louvre while they were both copying the *Infanta Margarita* by Velázquez. It was about this time, too, that he joined the group of artists who frequented the Café Guerbois, where heated arguments were carried on between the supporters and the opponents of traditional art. At the same period he used to visit Madame Desoye's Oriental art shop, La Jonque Chinoise, with Bracquemond, Philippe Burty and James Whistler.

He exhibited the *War scene of the Middle Ages* at the Salon in 1865, and this can be said to mark the end of his brief interest in history painting; portraiture now became his dominant concern. At the Café Guerbois, he met Emile Zola, the critic Edmond Duranty, and the painters who were later to be known as the impressionists. His style became more personal. At the same time he began to be involved with the subject matter of contemporary life. He was interested in the theatre world, in musicians, actors, and dancers; and he also attempted some paintings in the open air. (Before the rise of impressionism, this was almost unheard-of.)

He was called up in 1870, and spent the Franco-Prussian War in the National Guard in Paris. By this time his eyesight had begun to deteriorate, causing him great anxiety. He served at one stage in an artillery unit captained by Henri Rouart, his old school friend, with whom he renewed his warm friendship.

In October 1872 he decided to accompany his brother René to New Orleans, where his mother's relatives lived. In America he was fascinated by the great variety of scenery

and the habits and customs which were different from the ones he knew, and he thought at first that here he could gain a new stimulus for his work. But in the end he felt homesick for Paris, and he returned there in 1873. He resumed contact with his friends, who had moved from the Café Guerbois to the Café de la Nouvelle-Athènes.

His father died in Italy in 1874, leaving the bank in a precarious condition. That same year, 1874, marked the official birth of impressionism. Degas actively joined in the preparations for the first exhibition of the ' Société anonyme des artistes peintres, sculpteurs, graveurs, etc.', held at the premises of the photographer Nadar, in the Boulevard des Capucines, and showed ten works, one of which, the *Dancing class*, clearly indicated his artistic maturity and the key to his future development. He exhibited twenty-four more works with the impressionists in 1876, and twenty-five in 1877, in spite of misunderstanding and ridicule. In 1877 the exhibition was called ' Exposition des Indépendants ', on his advice, and he contributed twenty-five of his own works including a portrait of Diego Martelli (*pl. 49*), the first Italian writer to view the new artistic movement with interest and understanding. At the fifth impressionist exhibition (1880) Degas showed eleven paintings; to the sixth (1881) he also sent the famous statuette of the little dancer; he did not exhibit at the seventh but was represented at the eighth and last exhibition.

In 1880 he made a trip to Spain, and he experimented enthusiastically in etching with Pissarro and the American painter Mary Cassatt, who had chosen him as master. During the same period he began working more intensely and assiduously in pastel, and he also invented the monotype technique, carrying it to a high level. He stayed at Etretat in July 1882, and in September of that year went to Switzerland. In Paris his interest in the daily themes of modern life continued (these were the years when the feminine world of laundresses and milliners attracted him); and he spent a lot of time with his impressionist friends, who feared and respected his frank and sharp observations. After Manet's death their meeting-place was again transferred, this time to the Café de la Rochefoucault.

In 1885 anxiety about his eyesight became more acute; meanwhile, he was developing complex technical experiments with disciplined energy. He was painting dancers and nudes as pretexts in his search for solid, flexible form and bold, deliberate rhythm. In August he stayed at Le Havre and Dieppe, and met Paul Gauguin, in whom he was to retain a certain indulgent interest.

He visited Naples, for family reasons, early in 1886. Increasing concern about his sight forced him to abandon oil for pastel almost entirely. When he returned to Paris, he was ready to show fifteen works at the eighth impressionist exhibition, including the ten famous pastels of female nudes. But the derision of the public and press, and his own retiring disposition, decided him not to take part in any more exhibitions, and from then on only Durand-Ruel, the impressionists' dealer, succeeded in obtaining a little of Degas's work.

His sight became weaker all the time, but he still exploited all the graphic and chromatic possibilities of pastel, with ever greater technical expertise. During this time he became interested in collecting: an entire storey of his house was given up to his collection of paintings by his impressionist friends, and by El Greco, Ingres, Delacroix, Corot and other masters. In 1893 Durand-Ruel showed a group of Degas's monotypes. From then on, Degas found work more and more exhausting, and inactivity more and more distressing. Information about him becomes more uncertain and fragmented from this time: we know that he visited Saint-Valéry-sur-Somme in 1898, and that he lived an isolated life, meeting only a few old friends like Bartholomé, Daniel Halévy and Henri Rouart, with whom he often stayed for holidays. His health was declining (in 1904 he had to treat his weak lungs in the Vosges mountains), and his sight was by now a mere glimmer. Yet somehow he continued working. Isolated, irritable, even forgotten, and as if bypassed by events, he turned to sculpture with greater intensity.

Fresh sorrow struck him in 1912: his friend Rouart died. In the same year he had to leave his house and studio in the Rue Victor-Massé, as it was to be demolished. Suzanne

Valadon, Utrillo's mother, and one of Degas's old models, who was now a painter herself, helped to find him a new home in the Boulevard de Clichy. Degas was unhappy in his new house, and used to drag himself blindly around the streets of Paris, risking his life. By then his own paintings were fetching high prices in the salerooms.

The war must have aggravated his suffering; he was probably barely conscious of the historical events of his own painful last days. He died on 27 September 1917. At the age of eighty-three, death must have seemed friendly and compassionate to him; indeed he had already written in 1893: ' I work with the greatest difficulty, and yet I have no other joy.'

Works

In the context of an artistic society which has become increasingly favourable to the creative virtues, the figure of Degas is not an easy one to understand and define clearly, either in relation to the development of art as a whole, or to the art of his time. His work leaves comparatively little scope for interpretation in terms of influences; more than most artists, he exemplifies the dictum of the existentialist philosopher Husserl that 'a discovery is a combination of instinct and method.'

The convenient classification of Degas as a 'painter of dancers,' a description which would apply better to Lancret, for example, or, in a different sense, to some of Lautrec's work, does no more than identify a number of more or less agreeable, although relatively incidental, thematic elements, without raising the problem of a whole philosophy of art. Nor is it possible to define his art as 'realist,' even if this is taken in the broadest sense; in his response to an essentially inward truth, Degas used chiaroscuro and drawing in an idealized, partly abstract way. Finally, there is his connection with the impressionists. In spite of his personal and artistic contacts with them, his passionate partisanship, and his participation in their group exhibitions, he was never really an impressionist himself.

He was solitary and uncompromising, in his life as in his work, and perpetually dissatisfied because he was tormented by his sense of an intangible perfection for which he vainly struggled all his life. Every experiment involved him passionately, and he was continually hopeful of finding apparently very simple means of expressing the complexities of reality. Degas, as Jamot has noted, could create relationships which no one before him had seen, particularly the reality of a body living in harmony with whatever surrounded it. Yet he was able to take a detached view, as a contemplator of the work, so that the secret artifice separating him from the work was almost tangible. He was a painter of contemporary life – lacking Manet's elegant scepticism or

Renoir's joyful participation – because in him there was a violent clash between fidelity to nature and an almost tragic passion which was resolved only in action. 'Art,' he said, 'is vice. You cannot marry it legitimately, you rape it. Say art and you are saying artifice. Art is dishonest and cruel.' So this great and severe artist, of rare and restless intelligence, concealed beneath a decided and even opinionated manner 'the self-doubt and the lack of hope that he would ever satisfy himself' which were the manifestations of his eternal inner contradictions.

As a young man, he spent much time making copies in the Louvre (agreeing with what was to be Cézanne's creed: 'the Louvre is the book where we learn to read'), copying Dürer, Mantegna, Goya, and Rembrandt, and going to Barrias's studio and then to Lamothe's. With Lamothe, as well as studying original works of art with admiration, he also became immersed in Ingres's theories of art, and particularly in his passion for drawing, expressed in words which, for Degas, had a fateful significance: 'Draw lines, young man, many lines, from memory or from nature; it is in this way that you will become a good artist.'

After his first long stay in Italy, Degas, equipped with a strong and assured drawing style, might well have stepped into the position of the great academic painter of his time, the successor to Ingres. His Italian trips of 1856-9 provided the essential return to sources based on a rigorous process of selection which was consistent with his desire to experiment and to consolidate his knowledge. He carried out all this with an energy, and a severe inner discipline, which were already setting their seal on his character. To Degas, the time in Italy was 'the most wonderful period' of his life, while his notebooks, especially in the short and intense years of 1853-61, were filled with precise and significant drawings.

The earliest ones (1853-6) record the work he did copying in the Louvre print room and in the museums of southern France. He drew antique reliefs, classical sculpture and the Parthenon frieze (from casts), as well as the Renaissance painters and Raphael; perhaps this was partly owing to

the influence of Lamothe, who was a follower of Ingres. At the same time he made copies of Ingres himself, as well as of David and Flandrin; in addition, his preoccupation with exploring the resources of drawing led him to copy grotesques and caricatures by Leonardo and the mannerists. Between 1856 and 1858 his sketch books clearly show his preferences among the works studied both in the Louvre and in the museums of Naples, Florence, Rome, Pisa, Orvieto, and Assisi and elsewhere in Italy. In the copies in oil, his constant preoccupation was with colour, whereas, in drawing, his interest and admiration was aroused by certain styles and features of line. By then, Hellenistic rather than classical reliefs interested him; Raphael's later paintings rather than his earlier; Poussin's baroque period; works of Rembrandt and Velázquez, and above all those of Signorelli and Michelangelo.

In the work of the years 1858-61, again spent partly in Italy and partly in Paris, generally doing quick sketches, he became preoccupied with problems of light and colour. He copied more Velázquez, but also van Dyck, Giorgione, Titian and Veronese, simplifying the relationship of the tones, as in the *Finding of Moses*; he copied Mantegna, Dürer, Holbein and Clouet, as well as Roman mosaics, Assyrian reliefs and Mogul miniatures; and, more rarely, he copied Raphael and Ingres. But Degas was by then also copying his contemporaries, like Constantin Guys – for whom Baudelaire coined the epithet 'painter of modern life' – and Delacroix.

Any attempt to deduce the direction of Degas's preferences from this evidence, produces a misleading initial impression of eclecticism. In fact, Degas was elaborating a system. He pursued his own closely disciplined and defined artistic rules willingly, obstinately, and with no recourse to intuitive spontaneity, but with a consistency which few others could match. He set himself the difficult aim, to all appearances artificial and almost mannerist in theory, of reconciling the balance and measure of classical rules with the deeper and more hidden significance of realism. Paul Valéry reports him as saying that 'a picture is a series of operations'; this is true, even of the copies and works done as

11

a young painter, for his expressed intention was to turn the *tête d'expression* (an academic study of facial expression) progressively into a study of 'modern feeling'.

The secret of Degas's personality, and of his withdrawn and undramatic life, resides in his single-minded determination, both as artist and man, to reject everything facile and obvious. He relentlessly pursued his highest ideal: identification with a sense of a living, moving truth which nevertheless remains, in essence, immutable.

The wide interests which he displayed in his formative period, his apparently contradictory tastes for fifteenth-century Florentine painting and Venetian colour, and his passionate admiration for Ingres as well as for Delacroix, prove that he cared deeply for the highest traditional values; at the same time, his own work is, in many ways, a conscious violation of tradition.

Other influences can also be perceived in these aspects of his personality, in his discipline, his perpetual disquiet, and his guarded receptiveness. It is clear that while he was in Rome in 1858, Degas made the acquaintance of Gustave Moreau ('a hermit,' he called him, 'who knew the train times'), and that they met frequently around the Villa Medici. The fact that they made copies together of the same painters does not merely illustrate their shared love of order and discipline, but shows that the two painters were able to meet in spite of the diversity of their artistic and personal attitudes. Moreau recommended Degas to record natural form, 'but in a fairly artificial way, so as not to destroy the spirit'. Indeed, we can be reasonably sure that Degas was under some sort of influence from him up to about 1865, when in the *War scene of the Middle Ages* he showed that he had not forgotten Moreau's *Athenians offered to the Minotaur*. The connection with Moreau, for whom Degas must have felt an equal blend of friendship and dislike, was probably partly responsible for Degas's attempt to rid the 'history painting' of the legendary and allegorical connotations which were demanded by current taste.

On the other hand his meeting with the novelist and critic Edmond Duranty in about 1862 promised to lead to other interests partly coinciding with his artistic ones; the

influence of literary realism caused him to become, like Guys, a ' painter of modern life '. Baudelaire's phrase came more and more obviously to have an immediate relevance in addition to its obvious prophetic significance. Other literary figures who frequented the same fairly close and exclusive group as Degas included Emile Zola, Stéphane Mallarmé, Amand Gautier, who passed on to him his own fascination with Oriental exoticism, and the young Paul Valéry, who was to be a perceptive critic of his work, particularly in *Degas, danse, dessin.*

One cannot omit the influences, quite apart from those relevant to his pictorial style, which can be found in the personalities and careers of his two idols, Ingres and Delacroix; their often rather self-conscious and exaggerated conflict served to remind him of the necessity of choice and the drama of a personal victory.

When Degas finished his apprenticeship and began working independently, he turned to portraits: of himself, his family, and his friends. Subjects, that is, who were easily arranged in the poses and attitudes he wanted, and whose individual characters he could express with familiarity and direct concern, capturing a free and subtle psychological atmosphere; in short, he could establish a bond between subject and artist.

The early portraits are few and precious: self-portraits, and portraits of his brothers René (*pl. 1*) and Achille. But while he was in Florence staying with his relations, the Bellellis, in 1856 and 1857-60, he had begun working on drawings of all of them, particularly his young cousins, in preparation for his first important composition for a group portrait, known as *The Bellelli Family (pls 4-5)*, painted in Paris between 1860 and 1862. The four figures are arranged across the picture from left to right, the three women turned more in spirit than in body towards the father. The composition, and the calculated relationship of the various parts, are somewhat rigid. The mother's dark clothes form a setting for the figure of one daughter, while the other is seated with one leg folded and hidden under her dress, arranged with a boldness and informality which seemed excessive to many critics, including Ingres. The father is viewed from the back,

his face in profile, sitting in an armchair in front of the fireplace. The atmosphere looks genuine and intimate, not only because of the exact observation of dress and the room, but also, and above all, because the arrangement of the figures draws the spectator into the domesticity of Baron Bellelli's household.

This painting, like others of the same period, contains echoes of a whole range of influences, ranging from Raphael to Titian and Bronzino; these were strong ones, in spite of the dominance of Degas's admiration for Ingres. Even though he was willing consciously and artificially to apply such influences, at the same time he paid careful attention to the actual pose of the model, with all the patience that a photographer required in the early days of photography.

From 1860 to 1865, Degas devoted himself freely to history painting: *Spartan girls and boys exercising (pls 2-3), Alexander and Bucephalus* (Basle, Hauggi Collection), *Semiramis building Babylon (pls 6-7), The Daughter of Jephtha* (Northampton, Mass., Smith College Museum of Art), *War scene of the Middle Ages* (Paris, Louvre). In this sequence the painter applied, in the academic tradition, a careful series of good drawings; many of the figures show a studied beauty in the details, perhaps explored at length in his occasional models from the street. In spite of the archaic atmosphere, the inorganic quality of the composition, and the unconvincing, crude backgrounds, the series is notable in Degas's development. He shows considerable graphic strength in the analysis of each figure (a quality also found in the portraits), and he had clearly already made a close study of the anatomy and movement of horses. Presumably he had already been going to the races to make studies.

In addition, the history series marked his first connexion with the theatre: *Semiramis building Babylon (pls 6-7)* was inspired by a successful Paris production of Rossini's opera *Semiramide.* This connexion was to be taken up again six years later in the controversial *Mademoiselle Fiocre in the ballet ' La Source '* (Brooklyn, Museum of Art), but in this, only the subject matter preserved the link with the theatre world, since the composition was realized in static and conventional forms.

14

However, portraiture remained the dominant preoccupation; even the link with the theatre did not come about directly through Degas's visits to the dance foyer of the Rue Le Peletier, but was first formed through his friendship with musicians such as Désiré Dihau, bassoonist at the Opéra. The principal factor in his development at this stage was the minutely calculated compositions of his portraits. In the *Woman with chrysanthemums (pls 8-9)* he refined linear uncertainties and improved the studiously bold layout on a sort of blotting-paper in deference to the vogue for a Japanese flavour familiar for some years through Bracquemond's engravings, and also in connexion with the viewpoint of certain art photographs in which the figure is confined to the side of the composition. *Hortense Valpinçon as a child (pls 14-15)*, and the *Portrait of an unknown woman (pl. 10)* confirm the masterly thoroughness of psychological identification and formal perception of the greatest series of portraits. This development had already taken place, to some extent, in the various paintings of the guitarist Pagans playing in front of Degas's father, Auguste Degas (*pls 17-18*), but even more in those of 1868-72 devoted to the musicians of the Opéra orchestra.

In these, every figure remains perfectly recognizable. While the field of vision is broadened to be unexpectedly blocked by the backs of the audience in the front rows, flickers of light pass over the heads – which face this way and that – to create a restless impression of expectancy in the audience. The spectators' heads, however, cut the picture across horizontally. More important, their solid, dark shadow and the light from the stage causes the sudden and brilliant disclosure of the background, with the dancers dazzling in their stage costumes. Gradually, the accessory theme became the main theme. Portraits of musicians and the audience gave way, as the primary centre of interest, to the performance, with all the formal and dynamic requirements of composition which such a subject demanded. This theme was presented in a sort of fantastic contrast with that of the spectators, as an imaginative escape from the exact observation of reality by which his analysis of people in the audience is inevitably kept in check.

When Degas began to go to the dancing classes of the Opéra, the school was in the Rue Le Peletier. It was known by all ballet lovers and had become famous when established artists like Taglioni or Essler were there. It was lit by gas, providing suggestive, illusory effects of light and colour which must have delighted Degas. He became interested in the dancers, in the movements and poses he could explore in their various steps and positions.

Each painting occasioned an extensive series of studies. In fact he watched the dancers not only when they were at the bar, resting or in *porte-de-bras*, but every moment of their long hours of practice, weariness, rest: when they were paying attention to their master's criticism, and when they were at ease, when they stretched, yawned or adjusted their costumes. In the end he knew every technical detail that troubled these girls, the so-called *rats*, often from humble backgrounds, who were subjected to exhausting tests of skill and stamina. He knew how to value with detachment every subtlety of their exacting practice, following their movements in pencil, and he seems at times to feel a subdued affection for them. It is as if the delight of discovering the theme had encouraged a secret identification with it. In the paintings of the orchestral musicians and of the audience, the effects of light and shadow on the figures, and the artist's involvement with their characters, tend to assume more importance than his interest in the arrangement of groups in a well-defined space. In the ballet paintings, on the other hand, work, space and figures are integrated with almost too great a diligence; the rooms are perfectly constructed in perspective, the human body is analysed ruthlessly, every part fitting together, the gestures and poses are carefully balanced, the juxtapositions meaningful, and everything responds to the environment.

In 1872 Degas painted *The Dance Foyer at the Opéra (pls 26-7)*, in which his clear commitment to the meticulous examination of the details, from the walls to the floor, to the doors, to the few furnishings, emphasize his concentration on his theme. In the process of assembling elements for his exploratory analyses, he was eventually to alter his early layouts completely; this work points the way to a sequence

of experiments which was to lead to a still unforeseeable conclusion. The dancers' dresses are alike; Degas was still not concerned with the possible intrusion of problems of colour. The light strongly reveals the bodies.

The portrait of Moraine, the dancer who succeeded the great Petipa, and *The Violinist*, both painted at about the same time, are true likenesses. A certain Dutch seventeenth-century mood, an amazing detachment, pervades the severe atmosphere of these paintings where no superfluity is allowed.

At the same time, in these lengthily prepared themes, he exercised a discipline, an ardent patience in working, an awareness that something can only be attained through constant effort. As Valéry observed, the idea ' of achieving the freedom of using one's means well enough... is what draws from some men a constancy, an effort, endless exercise and torment '. So, in the end, drawing for the artist must really represent the ultimate temptation of the mind, the obstacle from which, more than from any other, he draws fresh courage.

As Degas was already intent on setting out and solving the complex problems of this theme – which took up many long and important years of his life – the trip to America came as a digression with little significance for the development of his work, although it may have appealed to something in his character. The landscape and the people were new to him; but exoticism, which had appealed to the young Manet, and which Gauguin pursued in his search for an unattainable freedom, only incidentally impressed Degas, who wrote to his friend Fröhlich: ' what new places I have seen, what plans have entered into my head . . . In this way I am accumulating plans which would take ten lifetimes to carry out.' It is as if he already felt with vital urgency that the roots of his culture and training were European, and that, more than anything, he missed Paris and its bustle and humour.

Thus, in spite of the bright colours of Louisiana, in the paintings of these months he was incapable of pursuing local and ethnic themes. The blind *Young woman in white muslin (pls 28-9)* is like a sad version of a later theme, for she seems to hold the lightness of the *tutu* in the loose folds of

her full dress. And again, in *The Cotton Market, New Orleans (pls 30-1)*, the large room is presented as if it were one of those well-known ones in the Rue Le Peletier, the diagonals and perpendiculars carefully designed. The stress is on the well-ordered arrangement of the figures, rather than on the quality of the cotton, the newspaper, or the book-keepers' registers; the painter is studiously concerned to fill every space, even the farthest corner.

He has explored each figure with a resurgent flow of historical realism. They are recognizable, brothers, uncles, cousins, clerks: a group of business men of the old South, and each of them consciously playing his proper role. Degas put all the foreign, non-Parisian flavour of the composition into the cotton, suffused in golden light.

He returned to Paris, and to his old themes; the dancers started again to rehearse and perform. He resumed his constant practice of drawing, and his striving for a seemingly unattainable perfection. He explored the theme of the dance audition in obsessive detail, concentrating on obtaining precision in the balance of the composition and especially on taking advantage of all the formal resources offered by the dancers' various movements. Motion stood still, but it did so in the vibrant immobility of the first striking of the pose. He tried new sharp lines for every figure, discovering in them unexpected rhythms which were accomplished through a refined and shrewd observation, sharpened by a certain graphic artifice. At the same time his spatial vision also benefited from this gradual widening of his means of expression. He adopted a viewpoint, above the stage, which showed the dancers caught in the dazzle of light outlining the figure and lighting up the edges of the *tutu* and the dresses, and which heightened the perspective.

Through all this tenacious concentration on his own particular slice of contemporary life there filtered recollections of Japanese prints. From these he learned the use of fresh perspective viewpoints, and the vigorous effect produced by apparently rigid lines which are unexpectedly softened. Simultaneously, he made use of his experience in photography, not so much for the composition of space and forms, or as a verification of reality for purposes of direct translation –

something he rarely permitted himself – but as a technical aid which could sharpen the eye, extending the possibilities of his new modes of perception. This means that he rejected none of the resources of his age; he adopted contemporary knowledge at every point in his scheme of things, with an exploratory fervour which is amazing even today.

The paintings of horses and racecourses (*pls 20-4, 46-7*) touched on the same problems as the paintings of dancers. Apart from Degas's priority over Manet in this subject, the early versions are charming documents of the Parisian *demi-monde* at the Longchamps races; they have an elegance which gives way in later paintings to a ruthless regard for the horse's quivering body, ' sinewy and bare in its silken coat '. In the contemporary scene this unusual theme was quite untouched. He made use of the famous multiple exposure photographs by Eadweard Muybridge, which were published at this time (1878-81) These revealed to artists the mistakes they had previously made in representing horses in motion. Armed with this knowledge, Degas gave a true rendering of the dynamic movements and the superb lines of the limbs. The jockeys' colours and the carriages of the spectators served as foils for the horses, in a space cut by diagonals and by increasingly bolder asymmetrical openings, yet precisely balanced by the easily recognizable background of the ridges and green slopes of Saint-Cloud. The composition is strictly balanced as a harmonious whole, with an illusion of a development in time confined in a limited space.

These paintings, created through a patient process of intellectual elaboration, reveal Degas's critical attitude towards his work. But they also help to set him apart as an autonomous personality among the cultural and artistic tendencies that had been circulating in Paris since Degas's early meetings with Manet and others at the Café Guerbois and the Café de la Nouvelle-Athènes. The proud, aristocratic certainty which characterized him, even when he mixed anonymously in a crowd, became, in his painting, a detached but wary regard for contemporary life. His relationship with the impressionists was one of independence and ironic lucidity. He had many friends among them, but, although he and they had identical interests and methods as far as

public relations were concerned, there was never any question of his sharing their artistic principles. While taking part in seven out of their eight exhibitions, he proudly repudiated their theories, and laughed at ' these fellows who clutter the fields with their easels ', who worked doggedly from nature, almost, as he said, ' as if art did not live by conventions.' He himself resorted to convention when, for instance, he worked from sketches or photographs in his studio, accustoming himself to select only the ' necessary ', that is, only what had captured his imagination. And, in keeping with his sarcastic comment that ' the air that one sees in the paintings of the masters is never air that one can breathe ', he rarely turned his attention to landscape.

On the other hand his independence of the impressionists did not rest solely on this marginal objection to ' open air ' painting. Other essential differences lie in his constant intellectual effort, in his patient assembly of the results of his analysis, in his rational testing of the data produced by his imagination, in the ' artifice ' which intervenes even in his use of light; and in his self-neglect, shutting himself up with severe, exhausting attacks of fever, brought on by overwork. But while his spirit of rational commitment to the subject matter of contemporary life led him to join in discussions with his impressionist friends and to show in their exhibitions, in order to challenge official art with his sharp and sensitive intelligence, he was also convinced, through his friendship with Duranty, that a new movement in painting could only come about through a new conception of reality.

Even here, his point of view was entirely original. It seems to reveal traces of social comment, in some of the weary, despairing, even clumsy poses of the little dancers at the ballet school, or in the choice of humble subjects, such as the laundresses painted earlier by Daumier, or again in the gently biting irony of the treatment of women singers at the *cafés-concerts,* a theme which was to come bitterly alive in the work of Lautrec.

Realism, was then, a pretext: whatever the special significance, in every case ' it is a question of summing up life in its essentials; the rest is to be done by the eye and hand

of the artist'. *Women on a café terrace, Two laundresses (Women ironing) (pl. 53), Laundresses* (New York, H. J. Sachs collection), even *The Millinery Shop (pls 56-7)*, avoid the worldly intimacy which delighted Manet, who, perpetually en route for the Faubourg Saint-Honoré with Méry Laurent and Mallarmé, always inclined to seek to capture the exquisite transitoriness of beauty. Degas used his models to discover the contrasting opposition of light, to integrate every object into his vision with equal compositional value, to discover new formal possibilities in the amazing momentariness of every pose. The boldness and total spontaneity of his solutions conceals the laboriousness of his investigation.

Exhausted women, ironing, droop wearily and yawn, throwing ghost-like reflections on the wall (*pl. 53*); a singer (Cambridge, Mass., Fogg Art Museum), by the straight downward line of her black glove, seems barely to restrain the vitality of her presence from crossing the real and psychological distance which separates her from the spectator.

Degas's position in relation to realist and impressionist painting is implicit in his works; it cannot be deduced from letters, biographies, or the recollections of friends alone. On the other hand, some information, thoughtful even if indirect, can be drawn from a pamphlet by Duranty, published in 1876 and entitled *La nouvelle peinture, à propos du groupe d'artistes qui expose dans la galerie Durand-Ruel*, a provocative essay in which the author, while avoiding the word 'impressionism', certainly had the movement in mind throughout. How much Degas effectively contributed to drafting the pamphlet is not as relevant here as its revelations about the nature of the debate and of the differing ideas held contemporaneously by members of the group.

Duranty had already been involved during the previous decade with putting forward some of the motifs, common to the literature and art of his time, deriving from the observation of real life. In fact, like the Goncourt brothers, he had treated the narrative content of his own stories in this mood, leaving the field open for Zola's naturalism.

But, as early as 1856, he had written that from his observation of life, everything appeared to be arranged ' as if the world had been made uniquely for the painter, for the eye, to enjoy '. However, his personal approach to art was tinged with literary, and even more, with social preoccupations, based chiefly on an admiration for Courbet. Perhaps he recognized in Degas, alone among his contemporaries, the careful and undeceived observer of modern life and therefore the only one with whom he could discuss such problems with sincerity. In *La nouvelle peinture*, the ideas emerge obviously and clearly from a cultural background of a special and exclusive nature: they are, in fact, the products of a dialogue with Degas which clearly constitutes the basis of Duranty's whole system of reasoning. The pamphlet was regarded with suspicion, caution, and even disdain by the impressionists, who, with reason, read Degas's opinions into it.

Degas joined in the collective impressionist exhibitions from 1874 to 1886, excluding that of the year 1882. He agreed to the proposals and projects of his friends, but always made it clear that he did not want the exhibition to be revolutionary in character. He frankly admitted, too, that he considered himself different from his colleagues in that his work was not based, as theirs was, on a relationship with nature and the open air. He never gave up trying to win over as many artists as possible to his point of view, vainly hoping to persuade even Manet, who was always preoccupied with gaining official recognition by the Salon.

In the 1874 impressionist exhibition, Degas showed ten works in oils, pastels, and drawings of the races, laundresses and dancers; in 1876, twenty-four works, including *The Cotton Market, New Orleans (pls 30-1)*. But, on the whole, the differences between him and his impressionist friends became more and more obvious: ' You need natural life, I need artificial life. ' He found it impossible to persuade his fellows to ' look for new combinations in the methods of drawing ', which he considered more productive than colour. He remarked, ' It is fine to copy what one sees; it is much better to draw what one sees no longer except in memory '.

Degas sent to the sixth exhibition (1881) seven paintings and pastels, and also the little *Dancer, fourteen years old,* the only piece of sculpture exhibited during his life. It was included in the 1880 catalogue, but could not have been finished by that date. The little *Dancer* aroused amazement in the spectators; dresed in a stiff muslin *tutu*, her hair tied with a blue ribbon, and satin shoes on her feet, almost breathing, her muscles taut and alive, she was the picture of waywardness and refinement.

Admittedly, Degas already used his direct study of the bodies and movements of horses, in works of sculpture; but he did not inted this as an end in itself. It was an experiment, a suitable way of discovering new information about the pictorial transcription of these subjects; for instance, the *Horse at a drinking trough* was used as the model for the unfortunate painting of *Mademoiselle Fiocre in the ballet 'La Source'* His principal intention was to relate colouristic and dimensional elements to linear function. This involved him in the dynamic possibilities of form through an increasingly mature intuition. And although he had done a few sculptures before 1880, it is only from this date that he intensified his concentration on sculpture, which he found necessary for the study of form. The sculptures were modelled in wax (after his death Hébrard cast twenty-two original pieces), with the patience of the self-taught artist who does not destroy his early attempts, of the experimenter who disregards the outcome and fate of his pieces. All his anguished determination went into these pieces, resulting from the bitter distress which had separated him from the rest of the world. In his long and painful old age, when he could no longer see to paint for more than a short time each day, his hands still groped after form, and his studio became crowded with figures, both consoling and hostile.

The eighth impressionist exhibition in 1886 marked another important moment in Degas's career. He exhibited, as well as a group of pastel scenes of women in milliners' shops (sometimes his American pupil, Mary Cassatt, posed for these), ten pastels shown as 'a series of nude women, bathing, washing, rubbing down, drying, combing their

nair or having it combed '. It was the last time he exhibited – except for a brief exhibition at Durand-Ruel's in 1893 – and it marked his final alienation from the public. After this he became enclosed in his own world, devoting himself patiently and with a lucid passion to the themes and techniques most amenable to the refined perfection of his idiom.

To achieve this famous series of feminine nudes, Degas for months had filled his studio with arm-chairs, basins, and bath tubs. By this means he was able to observe the model with the greatest freedom, so that actions and gestures were for him, as for the model, slowly absorbed, naturally perceived, and at the same time he learnt the secret harmony of every vibration of the body. At the beginning of 1886 he paid a brief visit to Naples and wrote to his friend, the sculptor Batholomé, of his urgent desire to return to Paris and his ' flaming palace ', that is, his workshop, heated by a good stove. In this environment he prepared the pastels of women drawn in their almost animal nudity, in the natural immediacy of poses and gestures, ' as if they were observed through a key-hole '. The public were taken aback by these uncouth, vital figures, and hesitated between reprehension and admiration. His friends and critics were impressed; Huysmans, for instance, detected in the pastels ' a personal accent of contempt and hatred '.

Degas applied himself to this reality, not only by means of direct knowledge of the subject, but by recognizing in it a way to solve clear and urgent problems of motion and form. Every pose had immediate presence, in a long-drawn-out tension synchronizing with the graphic divagation of some of the detail, and more intensely, with the dense, unwearying pastel line which, while defining the figure, absorbed the linear style into a vibrant chromatic pattern which, in turn, can be interpreted as the acceptance of impressionist ideas. The drawing merged into the strokes of the pastel; the viewpoints and complex angles brought a fresh value to the sense of reality. The intense vitality of the nude was observed and transformed with a total detachment, and inessential elements resolutely avoided: these were necessary conditions for Degas, who was never attracted by the

'natural voluptuousness' of the old masters, nor even by Renoir.

Degas's acute reserve, his aloofness and his perpetual doubt and uncertainty, became more awkward and acute as the years passed and his physical difficulties increased. As has been said, he did not want to exhibit again; he agreed only to entrust Durand-Ruel in 1893 with a series of landscapes in pastel. These were done in his studio, and they preserved, by the link with what was left in his memory, a curious arbitrariness mixed with the clarity of particular preferences. If in fact, the hills and fields of the racecourse backgrounds are recognizable as such, this is owing to the necessity of forming a balanced composition. On the other hand, in *Women combing their hair (pls 38-9)*, the natural setting is outweighed by the essential presence of the figures. The landscape is absorbed clearly into the ground, binding the composition together, attracting the light, and defining the overall colour of the painting.

When Degas was in Boulogne and Trouville in 1869, he had made pastel sketches of seaside scenes which were discovered in his studio after his death. Between 1876 and 1877 he did other seaside sketches, but with figures, including bathing scenes in which the tiny figures were used to solve problems of colour rather than space. The twenty-one pastels of 1890-2, and those of 1898, make a simplified record of his travels and trips as seen through the eye of memory. When his friend Halévy asked if they represented states of mind, Degas replied, brusquely and without self-satisfaction, 'States of eyes! We do not use such pretentious language', which reaffirms, even here, the mental structure of all his work, his critical detachment and the operation of his choice of objects, considered apart from any emotional and sentimental conditions.

It is difficult to follow Degas's work logically or with any order from the 1893 exhibition to the years before his death. Shut up in the privacy of his house, where many rooms were given over to his collection of other men's paintings, he still strove to work with a final glimmer of sight. 'His pastels became multicoloured fireworks where all precision of form disappeared in favour of a texture that

glittered with hatchings ' (John Rewald). He was still doing dancers, but also nudes, sometimes modelled in condensed form, and accomplished with a freedom of invention equally removed from academic formulae and immediate acrobatic effects, and yet they were modern and unconventional, and, like Rodin's work, were produced with a lucidity that directly captured the human form and was sustained by a mental discipline that never tired of its ' beautiful architecture '.

Degas, like Monet, loved to return again and again to the same subject, in endless variations of handling and viewpoint, creating an extraordinary relationship between the exploration of the subject and the use of imagination and memory, released ' from the tyranny which nature exercises '. In his last years his technical mastery was greater than ever, and could be adapted to more exacting experiments. Pastel had become his exclusive and most suitable medium; and he had invented monotype, achieving unforeseen results, with the expert assurance of one who has invented a means expressive of, and identified with, his own type of work. He tried new approaches in his later years: the dancers were no longer studied in poses taken from actuality, or captured in the spectacular moment of the arabesque. The sense of connexion with the surroundings, or with a circumstance determining the pose, is slowly eliminated: backgrounds become indistinct, not directly linked with the theme. The dancers break forward into the foreground, almost bursting out of the picture space, and are brought together from a distance scarcely held within the range of the spectator. Their *tutus* are fringed with flashes of colour which vividly demonstrate the rotation of the figure.

At the same time he broke away from the unconcerned animal postures of the nudes. He searched for more complex and tormented poses, for more twisted and unusual distortions. The lines and colours of these poses break up in space, fraught with tension. Every element of the composition is drawn together in the dramatic brilliance of the strong motif, which, nevertheless, is soothing against the contrast of the unexpected gentleness of the pastel medium. This near-expressionism in Degas's paintings at the end of

his life seemed to bring out more intensely the content of his own previous statements of the 1870s. This was at a time when the impressionists were working within the confines of their own personal lines of enquiry, through a series of attacks and unavoidable crises, or were learning from fresh experience. Impressionism was open to criticism from other groups and personalities which set specific limits on its contribution; the clash of ideas opened new prospects to modern art. Degas's new conception of the object never palled, despite his determined faithfulness to the old themes. His study of effects of colour constituted an aid to knowledge, a means of renewing his hold on physical reality, a creative tension which enabled him to master the vibrant mutability of matter. Thus the structure of the bodies is no longer shown by firm lines, but by the corrosive effect of the coloured hatchings and by the painter's ability to capture the refractions of light in the interstices of juxtaposed bands of colour which fuse optically into one.

To attribute this process either to contemporary scientific explorations of colour, or to Degas's tragic optical deficiencies, is to give an incomplete interpretation which distorts the significance of the whole span of his work. Even if both explanations are correct in themselves, they are entirely subsidiary to the unrelenting will for experiment which nourished Degas's whole existence. This vision of the world, called ' inquisitorial vision ' by Pierre Francastel, was, in different ways, shared by Renoir; Degas achieved it through a process of ordered analysis of the shifting movements of light. He sought, by investigating ways of manipulating the horizontal-vertical relationships of the picture-surface, to obtain the greatest possible expansion of the perspective viewpoint. He also sought to define space by means of the grouping of ' heavy ' volumes which are stabilized in a fluid atmosphere by arrangement in counterpoint. The spatial and formal balance of Manet's *Fifer* is an instance of a comparable method.

As has been observed, Degas's consciousness of the experimental value of his work was clearly sharper and more mature than that of the other impressionists. Every pose was developed and carried to the extreme limits of the available

artistic possibilities. These decisive stylistic factors included his disciplined self-education, both literary and artistic; his strict; 'purist' training; his absorption of the *japonisme* of the period (it would be interesting to define its precise influences); the related link with photography, which affected not only his selection of a field of vision, but his studies in movement which seem like film sequences; his rejection of the values of traditional composition in painting; and his emplasis on brilliance of colouring. Through his own experimentation this brilliance achieved a luminous fusion of colour in the eye itself, rather than the sort of theoretical chromatic analysis pursued by Seurat and Signac.

Degas's steadfast perception of all the links in the development of these processes illustrates the importance of the effect he was to have on the art of today. But even more important was the influence he had on the artists of his own time. There was Henri de Toulouse-Lautrec, 'who, after early attempts in an impressionist vein, achieved a style of his own which showed a close yet free relation to Degas's, similar to the connexion that once existed between Degas and Ingres' (Rewald). There was Jean-Louis Forain, who dexterously combined elements from Degas and Manet, and who resolved these in his graphic work with a personal touch. Paul Gauguin, too, derived benefit from him, if only in his boldness of layout. Walter Sickert's friendship with Degas determined the former's artistic taste, and constituted a vital link between French and English culture of that period. Degas also had pheripheral influences on Félicien-Rops's graphic work, and a formative influence on Jacques Villon. Picasso's early work contains several obvious references to Degas, as does the work of Mary Cassatt, Suzanne Valadon, Edvard Munch, Edouard Vuillard and Pierre Bonnard, and the early work of Félix Vallotton.

There is no space here to dwell further on Degas's relationships with the other impressionists, or with Manet, which are apparent both in the choice of subject matter, differently handled, and in the stimulus provided by the use of pastel. Nor can we linger on the consequences of Degas's innovations in sculpture.

For the rest, even when Degas appeared to involve himself in the choosing of scenes from contemporary life, from the *Pedicure* (*pl. 32*) to *The Rape* and *Absinthe* (*pl. 41*) – to note the most typical and significant examples – he did not confine himself merely to passively recording them. This is illustrated by the pitiless lucidity with which he accepted the harshness of daily existence. His statements of this are impassive, unadorned by eloquent effects, committed without a trace of self-indulgence, and expressed, in his best works, entirely in and through his mastery of form.

Degas and the critics

The following is a list of the main documentary evidence: *Lettres de Degas*, edited by M. Guérin and D. Halévy, Paris 1931, and translated by M. Kay, as *Degas's Letters*, Oxford 1947; J. K. Huysmans, in *Certains*, Paris 1889, and in *L'Art moderne*, Paris 1908; Duranty in *La nouvelle peinture*, Paris 1874; P. Valéry, *Degas, Danse, Dessin*, Paris 1938, and *Monsieur Teste*; J. Fèvre, *Mon Oncle Degas*, Geneva 1949.

For monographs see: L. Delteil, *Edgar Degas. Le peintregraveur illustré*, Paris 1919 (catalogue of graphic work); J. Meier-Graefe, *Degas*, Munich 1920, translation London 1923, 1927 (biography); A. Vollard, *Degas*, Paris 1924, translation, as *Degas, an intimate portrait*, New York 1927; P. Jamot, *Degas*, Paris, 1924, 1939; D. Rouart, *Degas à la recherche de sa technique*, Paris 1945 (study of technique).

P. A. Lemoisne's four indispensable volumes, *Degas et son œuvre*, Paris 1946-9, contain a full text and 1500 plates, as well as a complete catalogue of his works; J. Rewald's *Degas, Works in Sculpture*, New York 1944, 1956, is a complete catalogue of his sculpture. It is relevant to mention, as well, sections on Degas in L. Venturi's book *Impressionists and Symbolists*, New York 1950; the important *Degas, Dancers* by L. Browse, London 1949, 1951; E. Rey's monograph of 1952; F. Fosca's of 1954; *Pastels of Edgar Degas* by D. Cooper, 1952; and the study by D. Catton Rich, *Degas*, New York 1951.

For more recent literature see the important essays in *The Burlington Magazine*, June 1963, by T. Reff, P. Pool, R. Pickvance, L. Vitali, J. Sutherland Boggs, K. Roberts and R. Alley.

Notes on the Plates

1 René de Gas with inkwell, c. 1855. Oil on canvas, 92×73 cm. Northampton, Mass., Smith College Museum of Art. This portrait belongs to Degas's early formative period, with its clear associations with the results of his study of the art of the past. His models at this time were mostly people he knew, and this helped in the psychological handling of the sitter, in this case aided by the severity of the composition which recalls, apart from Renaissance examples, his kinship with Ingres.

2-3 Spartan girls and boys exercising, 1860. Oil on canvas, 109×155 cm. London, National Gallery. This is the freshest and most lively of Degas's history paintings. According to his notebooks it was inspired by a drawing attributed to Pontormo, and it shows his inclination towards spontaneous composition. The painting, unfinished and with many *pentimenti*, remained unseen by the public for a large number of years. Later Degas decided to show it at the fifth impressionist exhibition (1880), where it must have seemed very incongruous alongside his later work. Various studies and drawings for it survive, and also two painted versions (Harvard, Fogg Art Museum; Paris, private collection).

4-5 The Bellelli Family, 1860-2. Oil on canvas, 200×250 cm. Paris, Louvre. It was in 1858, while he was staying in Florence with his relations the Bellellis that Degas began thinking of painting this very naturalistic family portrait, with the individuals represented in their daily familiar surroundings (a very unusual idea at that time) and bearing in mind the direct lessons of the great Florentine painters.

6-7 Semiramis building Babylon, 1861. Oil on canvas, 151×258 cm. Paris, Louvre. According to Lilian Browse, in *Degas, Dancers*, the painting should not be included in the traditional category of historical subjects, as it may have been suggested by a production of Rossini's *Semiramide* at the Opéra; if so, it would be evidence of Degas's first apparent contact with the theatre world.

8-9 Woman with chrysanthemums, 1865. Oil on paper mounted on canvas, 74×92 cm. New York, Metropolitan Museum of Art. This work shows Degas's interest in photography. The spectator's attention seems to be drawn to the mass of flowers in the centre, while the woman at the extreme right, is a fixed point outside the painter's field of interest; her pose almost suggests a subject caught unawares by a photographer's camera.

10 Portrait of an unknown woman, 1868-70. Oil on canvas, 27× 22 cm. Paris, Louvre. This is dated by some to about 1862, by others to 1867, but it should preferably be dated to the period immediately before his trip to America. ' This portrait ', wrote Georges Rivière, ' is a marvel of drawing. It is as beautiful as the most beautiful of Clouets, the greatest of the primitives.'

11 Monsieur and Madame Edmond Morbilli, 1867. Oil on canvas, 131×91 cm. By kind permission of the Boston Museum of Fine Arts, Robert Treat Paine Bequest. The reddish brown tone of the colour brings out the pictorial fluency of the background and the figures. This is achieved in a spirit reminiscent of both the Florentine mannerists and the Venetian painters of the early sixteenth century, and with great subtlety of composition, of line and of colour.

12 Study of hands. Oil on canvas, 38×46 cm. Paris, Louvre. The dating of this study is highly controversial and so is, in consequence, its relationship with the work it may refer to. However, there can be no doubt that the pose of the hands is similar to Baroness Bellelli's (*pls 4-5*).

13 The Opéra orchestra, 1868-9. Oil on canvas, 55×45 cm. Paris, Jeu de Paume. The choice of subject was motivated by Degas's interest in painting his friend Désiré Dihau, bassoonist in the Opéra orchestra. This is the first of the canvases devoted to orchestral musicians. The Frankfurt version followed, and then the *Ballet of Robert le Diable* (1872), where the stage and dancers were given greater prominence.

14-15 Hortense Valpinçon as a child, 1869. Oil on canvas, 91× 117 cm. Minneapolis, Institute of Arts. Degas had been able to meet Ingres through his friendship with the family of Paul Valpinçon, whom he often visited at Mesuil-Hubert in Normandy. Nothing remains of the large bust Degas made of Hortense as an adult (*c.* 1884), which was unfortunately destroyed by accident during the casting.

16 Mademoiselle Dobigny, 1869. Oil on panel, 31×26 cm. Hamburg, Kunsthalle. The sitter in this delicate portrait was well-known in artistic circles; she also posed for Corot and Puvis de Chavannes.

17 Lorenzo Pagans and Auguste de Gas, c. 1869. Oil on canvas, 54.5×40 cm. Paris, Jeu de Paume. See note to *pl. 18.*

18 Degas's father listening to Pagans, 1869-72. Oil on canvas, 77×60 cm. Boston, Museum of Fine Arts. Degas's father, Auguste de Gas, was an ardent connoisseur of music; Lorenzo Pagans was a Spanish singer and guitarist of high reputation.

19 Mademoiselle Marie Dihau, c. 1869. Oil on canvas, 39×32 cm. Paris, Jeu de Paume. Degas seems to have had some compositional difficulty in relating the ornately dressed woman to the piano. The subtlety of the colour combinations and the gentle insight into the firm and serious oval face recall some features of Vermeer's paintings.

20-21 At the racecourse, 1869-72. Essence on canvas, 46×61 cm. Paris, Louvre. The precise, fine outlines of the horses, and the strong, colourful patterns formed by the clothes of the jockeys and the spectators, have been achieved by means of a new technique, 'essence', in which oil is replaced by a more volatile medium, a spirit, permitting the colours to dry quickly and to appear clear and transparent, producing an effect not unlike watercolour.

22-24 A carriage at the races, 1870-73. Oil on canvas, 37×56 cm. Boston, Museum of Fine Arts, Arthur Gordon Tomkins Residuary Fund. Apart from the even distribution of figures on the racecourse, there is a remarkable harmony in the forms of the various horses, perhaps derived from the English manner (then in fashion in Paris), in the sky with its dreamy neutral-coloured clouds, and in the detail of the carriage, which, in its illusory feeling, seems to look forward to the work of Vuillard.

25 Woman with vase, 1872. Oil on canvas, 65×54 cm. Paris, Jeu de Paume. This was painted in New Orleans, possibly before the *Cotton Market* (pls 30-1).

26-27 The Dance Foyer at the Opéra, 1872. Oil on canvas, 32× 46 cm. Paris, Louvre. This work is first in chronological order, and one of the best-known, of the long series of paintings, numerous studies and drawings, inspired by dancers, by their arduous, disciplined exercises, and by their dazzling but strenuous performances.

28-29 Young woman in white muslin, 1872-73. Oil on canvas, 73× 92 cm. Washington, National Gallery of Art. This is another of the portraits painted in New Orleans. It is one of the most successful of those done in America, and one of the more unconventional, as it is painted in pale, pink tones, bathing the forms in a gentler light.

30-31 The Cotton Market, New Orleans, 1872. Oil on canvas, 74×92 cm. Pau, Musée des Beaux-Arts. The composition, in its subject matter of an interior with figures seen going about their normal occupations, and in the strict setting out of a repeated series of rectangles, seems to bear witness to a knowledge of the Dutch masters of the seventeenth century. It was shown at the impressionist exhibition of 1876, and was Degas's first work to be bought by a museum (1878).

32 The Pedicure, 1873. Essence on paper mounted on canvas, 61×46 cm. Paris, Louvre. Degas painted this in Paris, on his return from America. Recourse to such an unusual subject, using some ‘naive’ stylistic features to depict the setting, is a product of the cultural and literary stimulus of the realist circle, of which his friend Duranty was a prominent member.

33 Rehearsal of a ballet on the stage, 1874. Oil on canvas, 66×82 cm. Paris, Jeu de Paume. At this period, Degas, partly because of the influence of the realist circle, tended to prefer compositions of dancers exercing, practising and rehearsing, and these took precedence over the more limited compositional possibilities presented by the members of the audience. In this way the dancers' world was explored with sharp but human irony. The almost unreal figure of the dancer, turning gracefully, is contrasted, as in this example, with the figure of the dancer resting, who while waiting for the rehearsal to start tries a step, stretches, scratches her back, or relaces her shoes.

34-35 Melancholy, c. 1874. Oil on canvas mounted on panel, 19×24 cm. Washington, Phillips Memorial Gallery. Here Degas has captured a meditative, introspective state of mind. The glare of reddish light improves the balance, and seems to come from a fireplace on the left, lighting up the couch and the woman's clothes.

36-37 The Dancing Class, c. 1874. Detail. Oil on canvas, 85.5×75 cm. Paris, Jeu de Paume.

38-39 Women combing their hair, 1875-76. Essence on paper mounted on canvas, 31×45 cm. Washington, Phillips Memorial Gallery. This is one of Degas's first attempts on the theme of women in natural domestic poses. Later on and for the rest of his life he was concerned with this subject and always with clear, enthusiastic detachment. Here, three poses of the same model have almost certainly been used to produce a composition of three figures, as in a sort of film sequence.

40 Woman at a window, 1875-78. Oil on canvas, 62×46 cm. London, Courtauld Institute of Art.

41 Absinthe, 1876. Oil on canvas, 92×68.5 cm. Paris, Louvre. This is one of Degas's most famous works. It was shown in 1893 at the Grafton Gallery, London, where it aroused a scandal; though defended by Sickert and George Moore, it was so widely condemned that the purchaser, Arthur Kay, got rid of it immediately.

42 Café-Concert des Ambassadeurs, 1876-7. Pastel on monotype on paper, 37×27 cm. Lyons, Musée des Beaux-Arts.

43 Dancer with bouquet (Fin d'Arabesque), 1877. Essence and pastel, 65×36 cm. Paris, Jeu de Paume.

44-45 Ballet rehearsal on the stage, 1878-79. Pastel on paper, 52× 71 cm. New York, Metropolitan Museum

46-47 At the races: Amateur Jockeys, c. 1880. Oil on canvas, 66.5×82 cm. Paris, Jeu de Paume. Degas remained very attached to the subject matter of horses throughout his work. Here the layout is balanced by the diagonal positions of various subjects and by the vividly coloured jackets of the jockeys, while the horizontal aspect is emphasized by the outline of the hills. A train puffing smoke is passing along the foot of the hills as if ready to join the race.

48 Edmond Duranty, 1879. Detail. Tempera and pastel on canvas, 100×100 cm. Glasgow, Art Gallery and Museum. When this work was shown at the fifth impressionist exhibition (1880), J.-K. Huysmans wrote of it: ' No painter since Delacroix, whom he studied deeply,... has understood as well as Degas how to mix, and how not to mix, colour; no one at the present time can draw so precisely and with such breadth, and with such delicate colouring.'

49 Diego Martelli, 1879. Oil on canvas, 110×100 cm. Edinburgh, National Gallery of Scotland. This Florentine writer, while still a friend of the Macchiaioli (a group of Florentine late nineteenth-century realist painters) and a member of the group at the Café Michelangelo, was the first Italian to realize the value and quality of the impressionist painters.

50 La La at the Cirque Fernando, Paris, 1879. Oil on canvas, 117×77.5 cm. London, National Gallery. Degas composed this with

a very bold foreshortening, emphasizing the vertical perspective to an almost giddy degree, and in doing so decentralizing the figure and bringing about its precarious mobility.

51 Dancer on stage, c. 1880. Pastel on paper, 56×40 cm. Chicago, Art Institute. The direction of the legs in the foreground from the right hand corner to the centre makes the lines of the composition bold and very vigorous. Most of the dancers are outlined with strokes of contrasting colour, as if lit up in the dazzling artificial light.

52 Seated dancer lacing her shoe, 1881-83. Pastel, 62×49 cm. Paris, Jeu de Paume.

53 Two laundresses (women ironing), c. 1884. Oil on canvas, 76×82 cm. Paris, Louvre. This is a variation on a theme long worked on by Degas and which can be compared to the *Washerwomen* by Daumier. Degas started out on the same level of interest as Zola, but he depicted this naturalistic, daily task with a direct spontaneity in poses and gestures of exhaustion, setting the figures against the diagonal lines of the table, which seems to recall the stage. Picasso was to handle this subject in his Blue Period, concentrating on the theme of exhaustion with greater psychological emphasis.

54-55 Woman in her bath sponging her leg, c. 1883. Pastel, 197×41 cm. Paris, Jeu de Paume. This is one of the first of Degas's attempts on the famous theme of nude women, bathing, washing, drying, rubbing down, combing their hair, or having it combed, which were shown in the 1886 exhibition. The detachment of the artist's approach is as complete as the poses are natural, the models showing no embarrassment under direct observation.

56-57 The Millinery Shop, c. 1885. Oil on canvas, 99×109 cm. Chicago, Art Institute (Coburn Collection). Here the frivolous and brilliant display of hats – blending with the colours of the interior and contrasting delicately with the graceful and modest figure of the milliner appraising her own work – represents a special interpretation of the concept of ' still-life'; Degas never actually painted a still-life as such.

58-59 The Tub, 1886. Pastel on cardboard, 61×85 cm. Paris, Louvre. This is probably the best-known of the series of nudes of 1886.

60 After the bath, c. 1886. Pastel on cardboard, 54×52 cm. Paris, Jeu de Paume.

61 After the bath, c. 1886. Pastel on cardboard 71.5×49 cm. Rome, Galleria Nazionale d'Arte Moderna.

62-63 Dancers climbing a staircase, 1886-90. Oil on canvas, 39×90 cm. Paris, Louvre. Various studies and drawings for this painting survive. The subtle exploration of movements and gestures is repeated with overwhelming naturalness, while the layout of the painting has been very effectively simplified.

64 Woman combing her hair, 1887-90. Pastel, 80×57 cm. Paris, Jeu de Paume.

65 After the bath, 1890. Pastel, 68×59 cm. London, Courtauld Institute of Art.

66-67 Dancers in blue, c. 1890. Oil on canvas, 85×75.5 cm. Paris, Louvre.

68 The Morning Bath, c. 1890. Pastel on paper, 70×43 cm. Chicago, Art Institute. The immediate realist stimulus was more or less absent from Degas's work from about 1890 onwards. Not only is the nude here purely a pretext for the representation of space and form, but the relationship of the colours is boldly arranged in a series of variations of whites and blues.

69 Woman seated in a tub, sponging her neck, c. 1892. Essence on canvas, 55×66 cm. Paris, private collection.

70-71 Woman at her toilet, c. 1894. Pastel, 94×108 cm. London, Tate Gallery.

72-73 After the bath, woman drying herself, 1896. Oil on canvas, 89×116 cm. Zurich, private collection.

74-75 After the bath, woman drying her neck, 1898. Pastel on cardboard, 62×65 cm. Paris, Louvre.

76-77 Three dancers, 1899. Pastel on paper, 61×64 cm. Toledo, Ohio, Museum of Art.

78-79 Woman drying herself, c. 1903. Pastel on paper, 70×73 cm. Chicago, Art Institute. In this, one of Degas's last works,

the outlines of the arms and upper part of the body are the only definite graphic lines existing in the whole composition: the figure has in fact lost all its initial motivation in reality, and is used more as a means to bind the various parts of the composition together. The figure also exists as a factor in the relationship between the various other elements of the drawing, which now tend to become merely part of the continuous flow of colour, rather than define spatial objects. This in itself is totally expressionistic, and anticipates the achievements of the German expressionist movement, and its search for colour freed, by means of light. from any fixed reference to the main object.

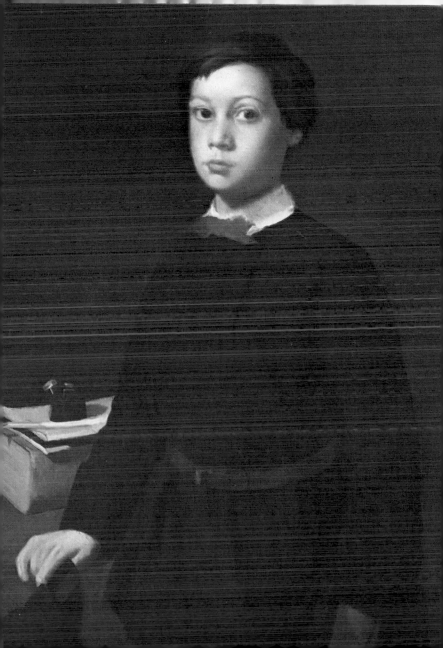

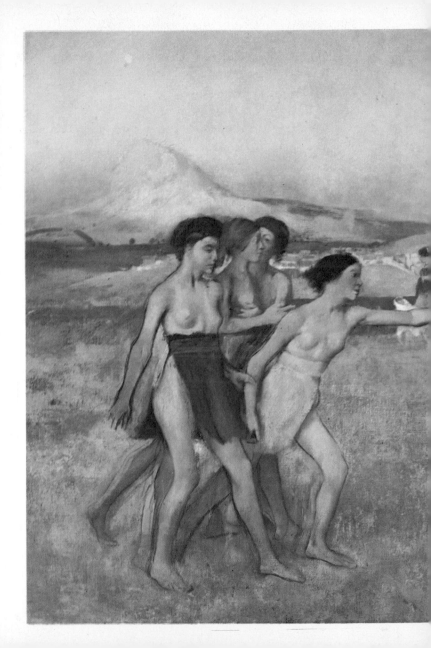

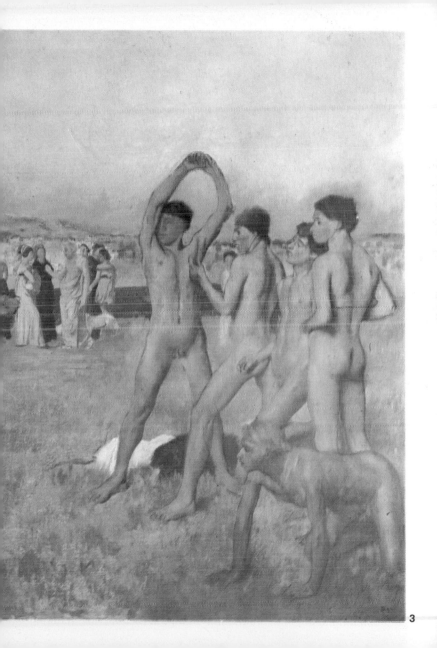

3

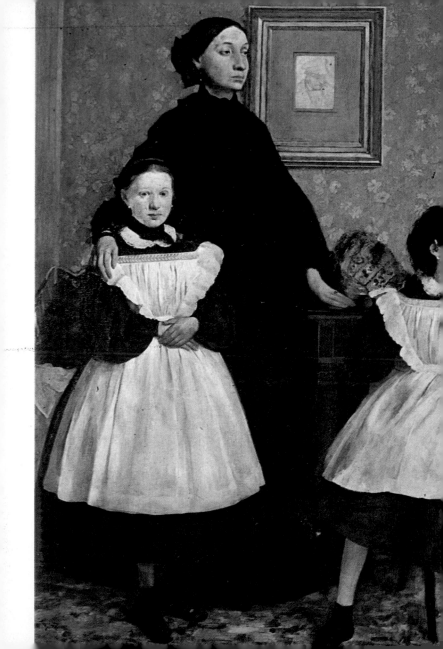

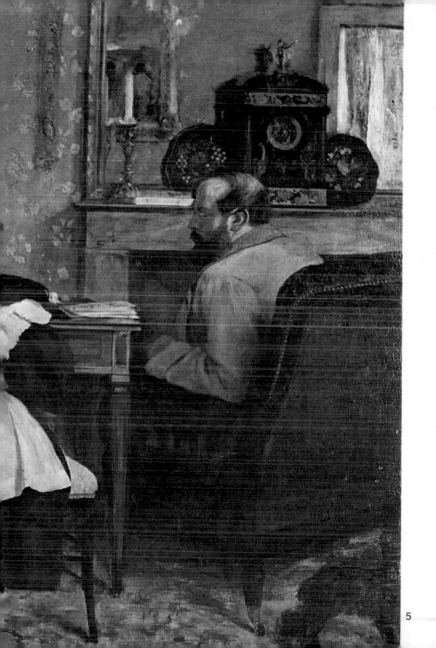

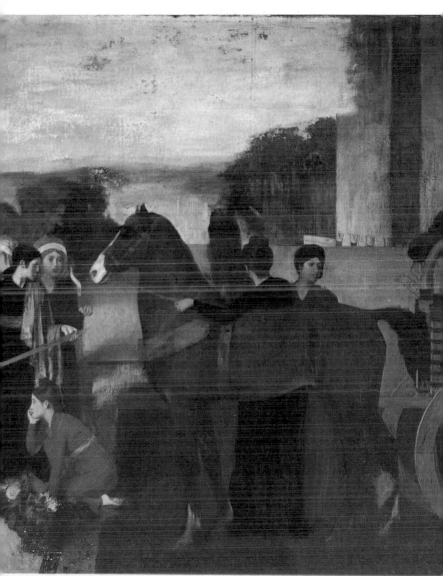

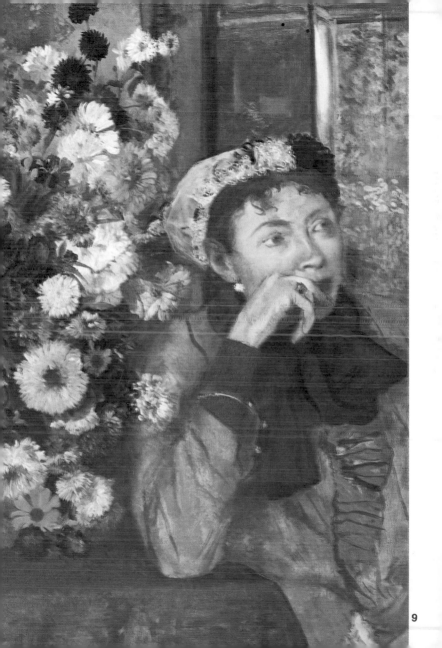

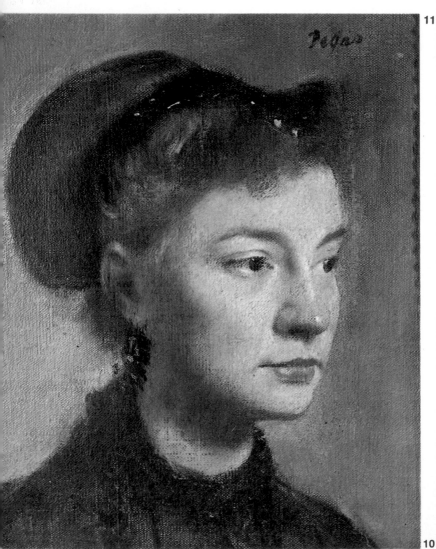

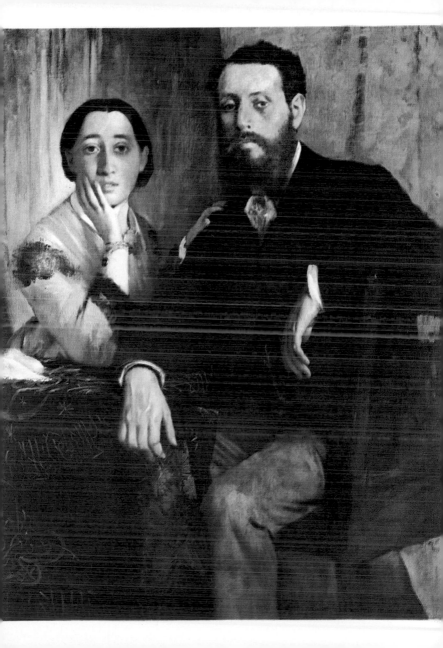

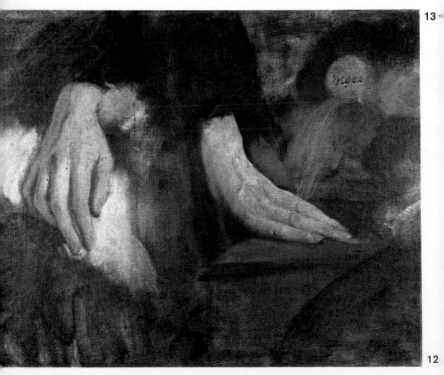

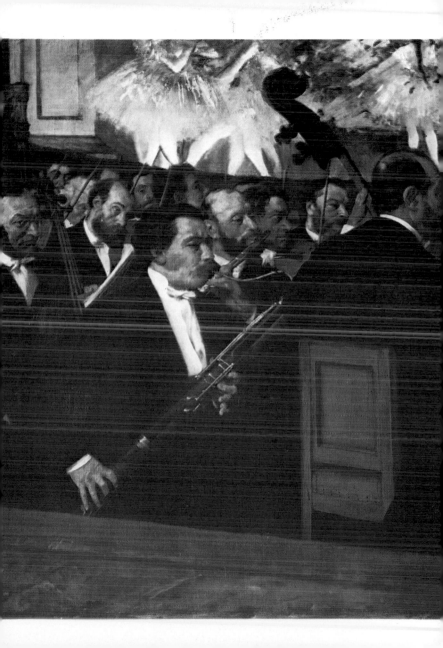

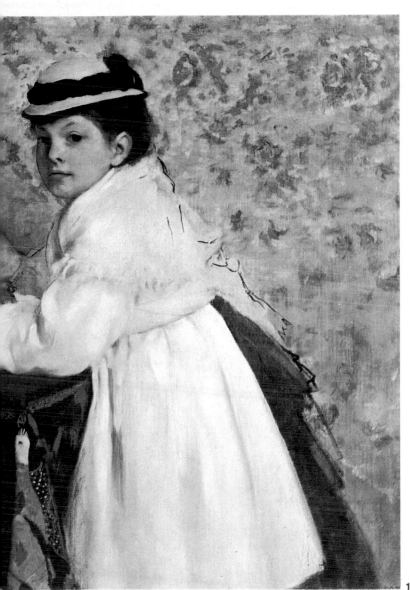

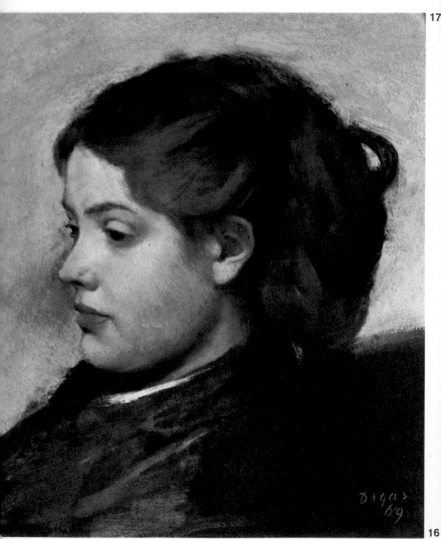

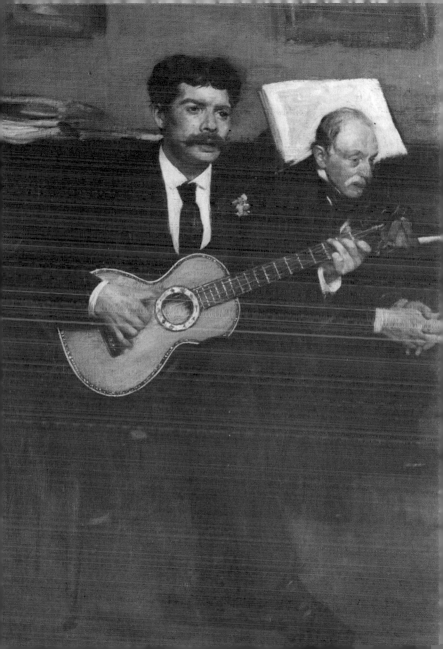

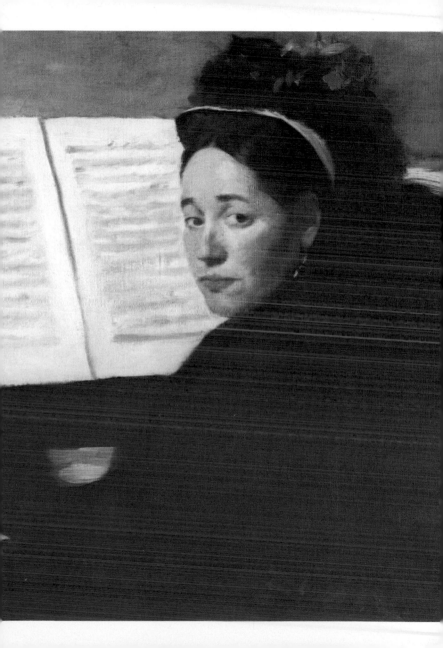

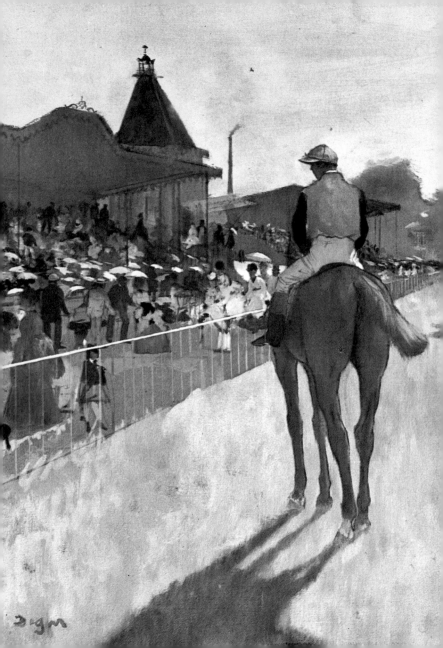

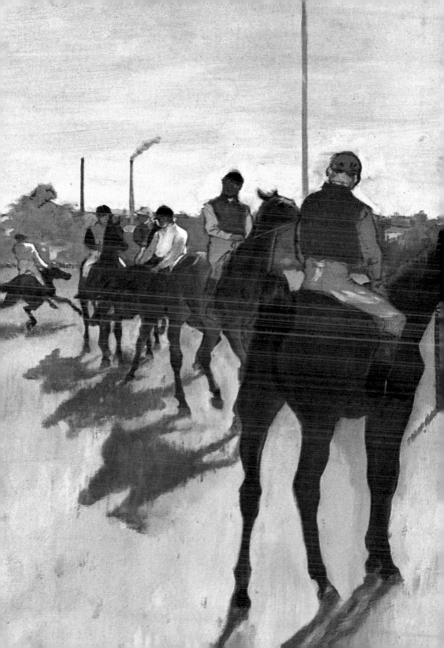

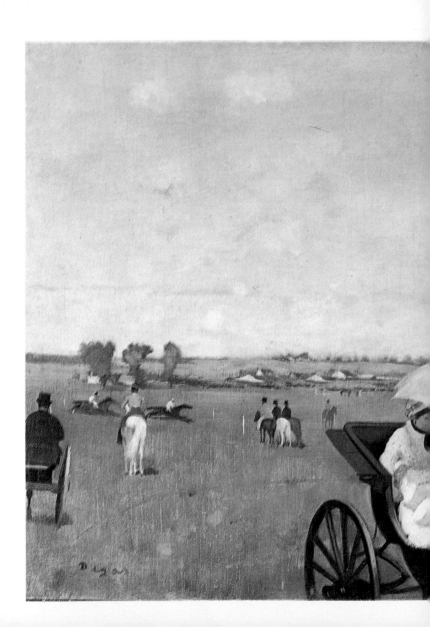

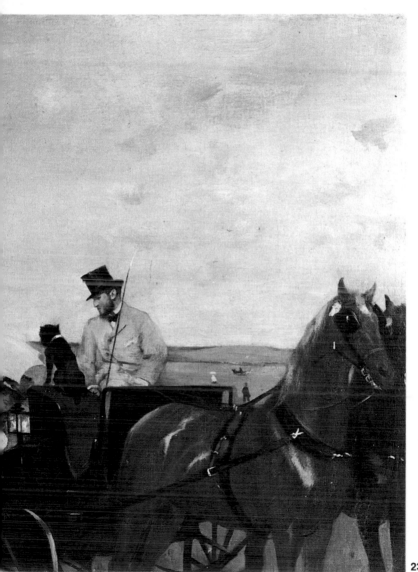

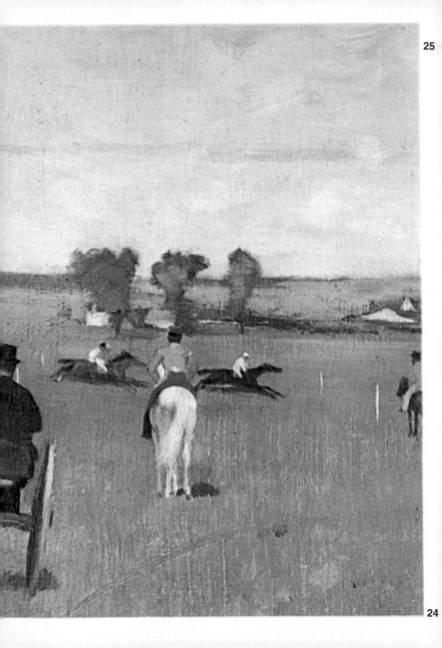

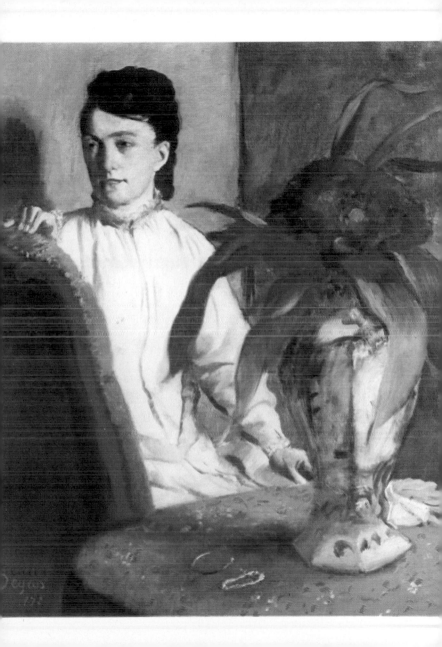

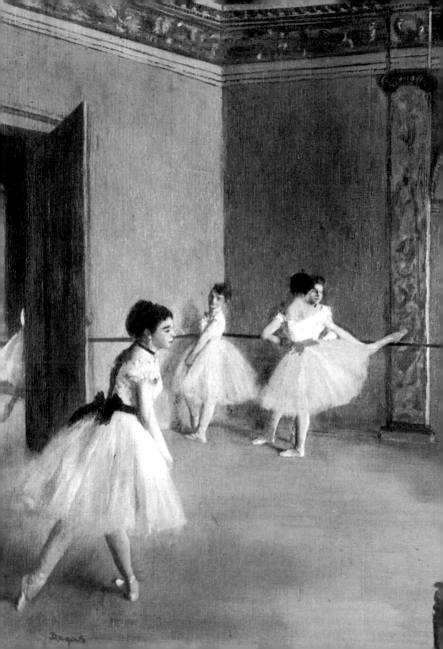

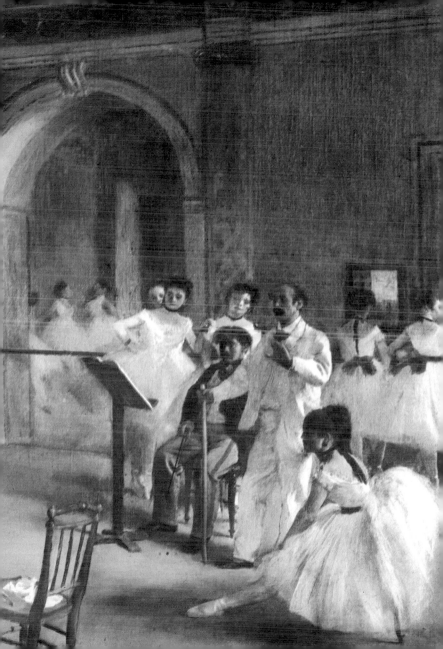

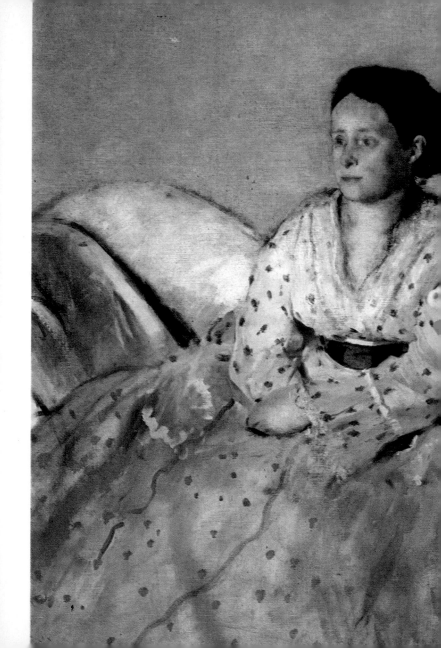

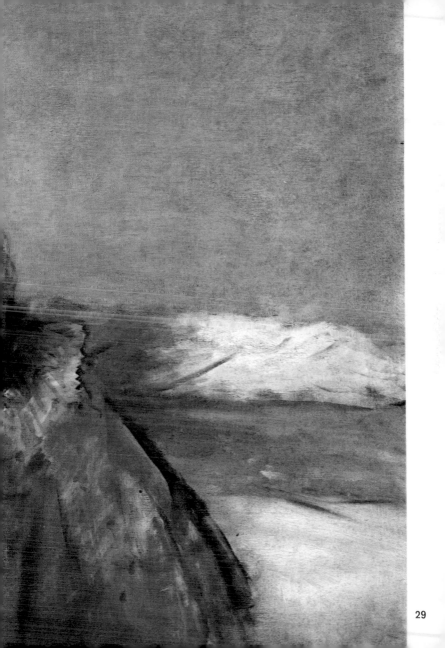

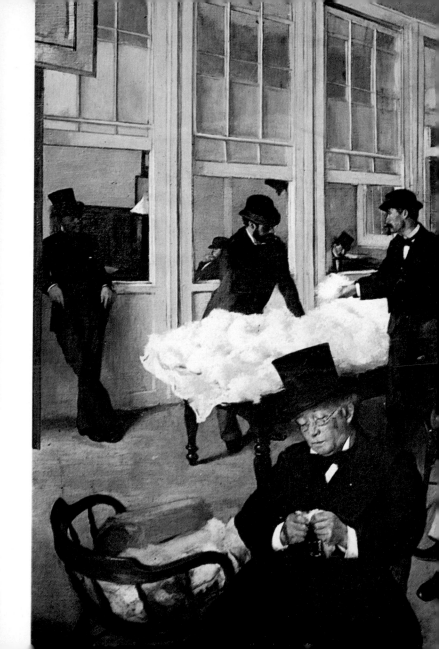

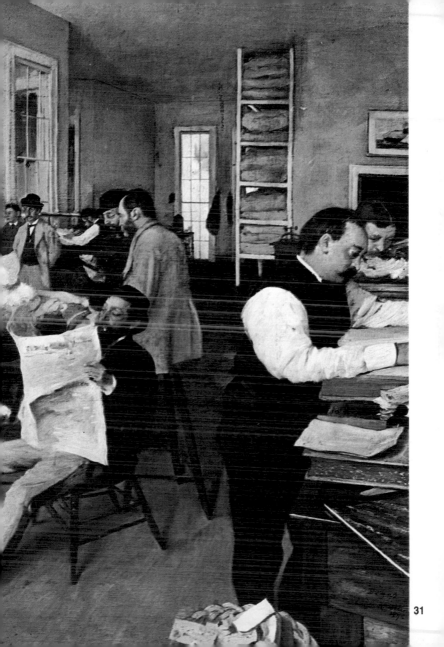

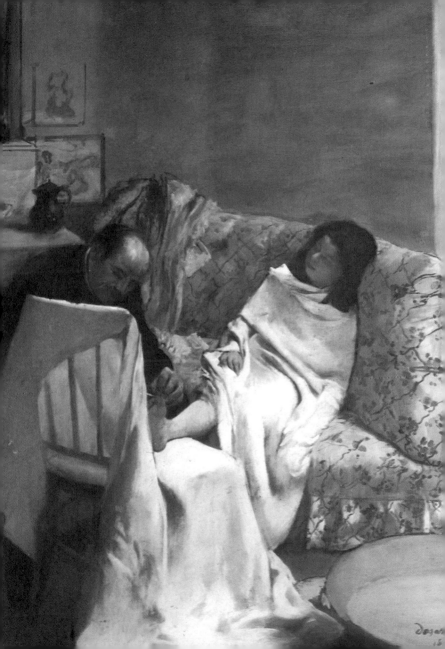

32

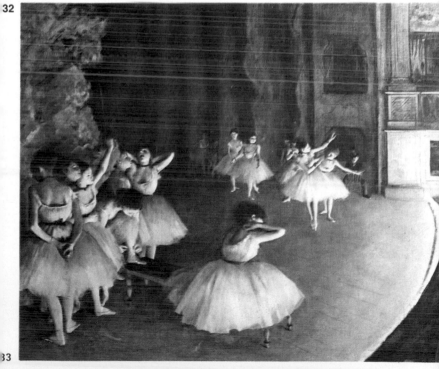

33

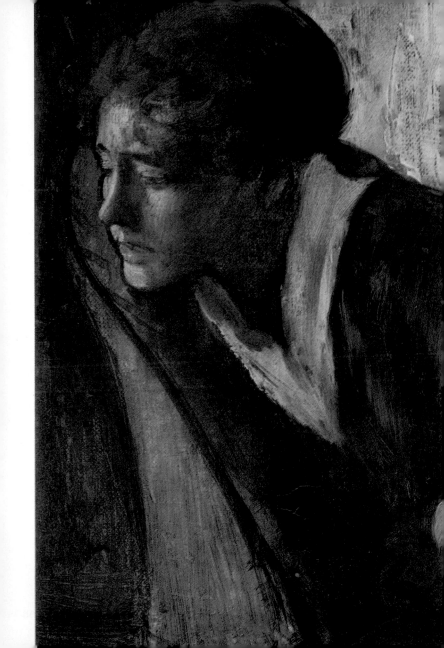

Degas

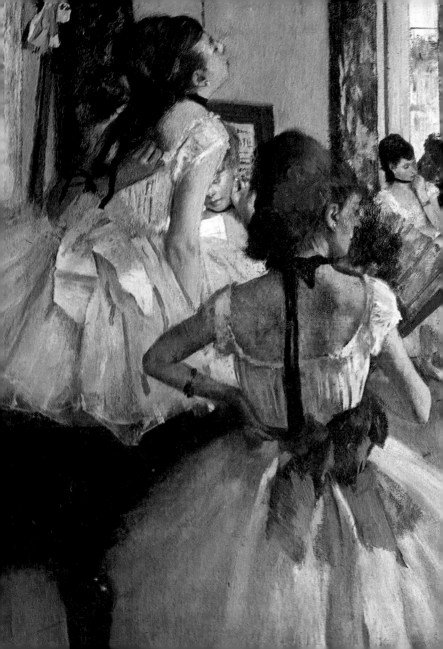

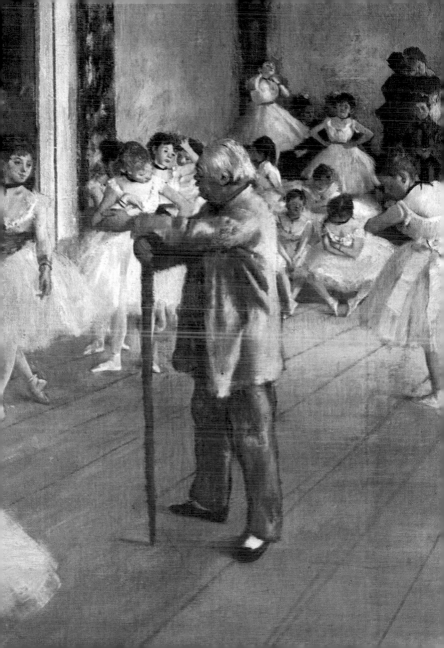

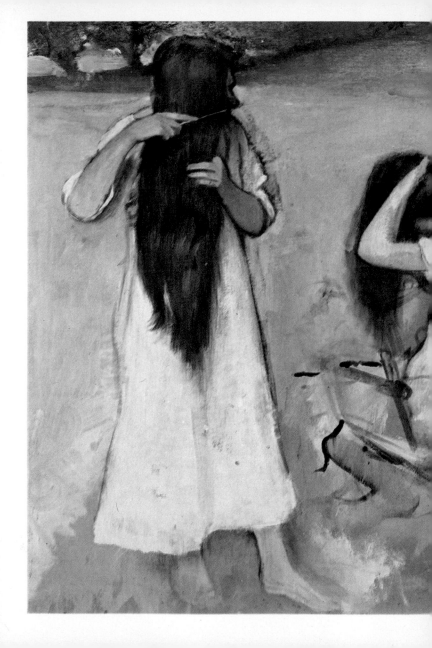

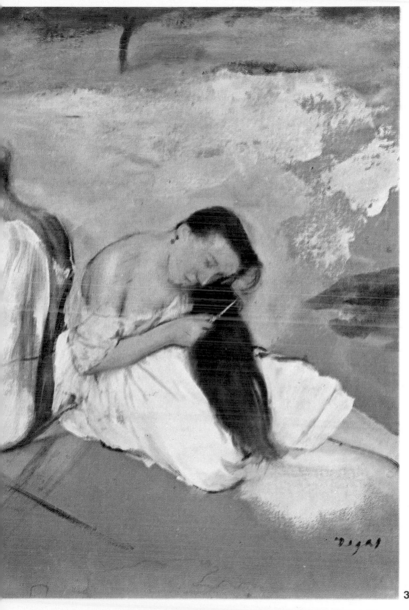

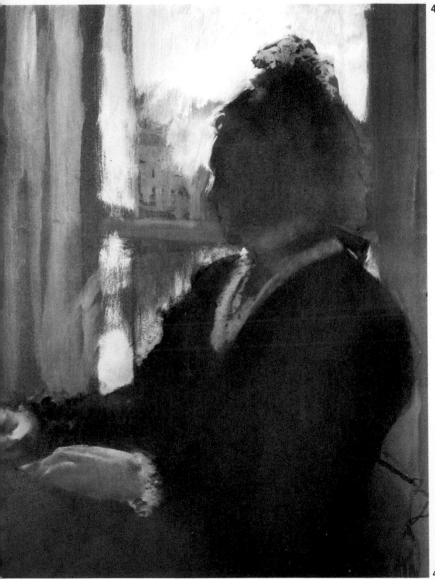

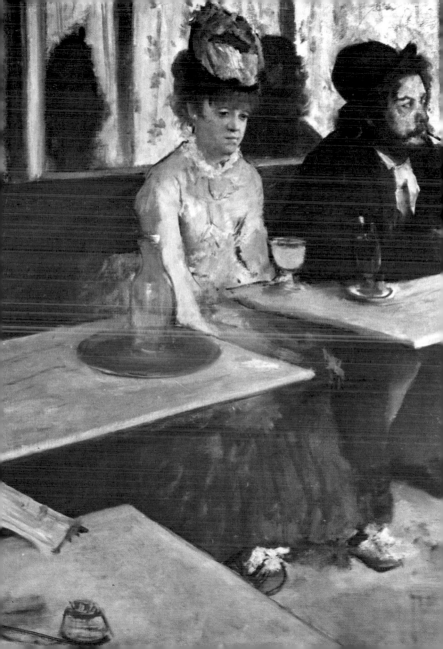

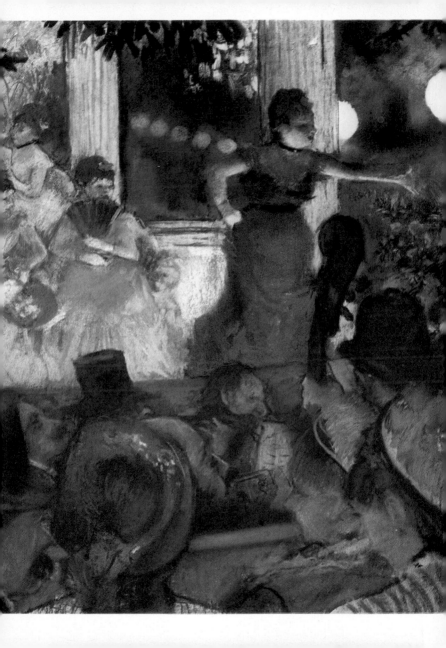

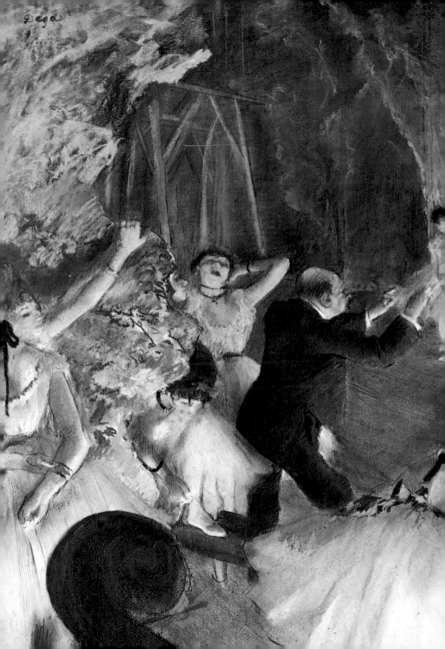

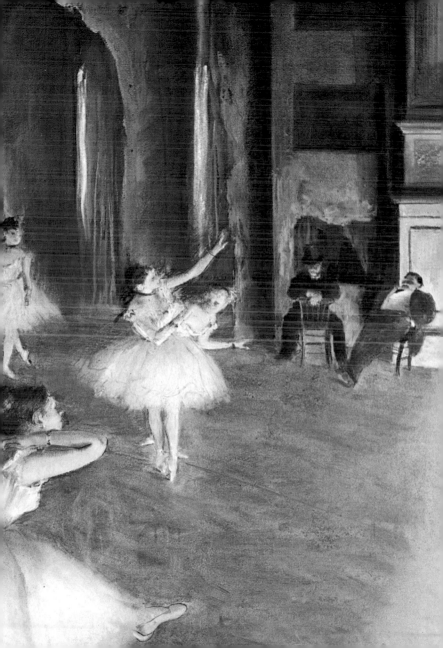

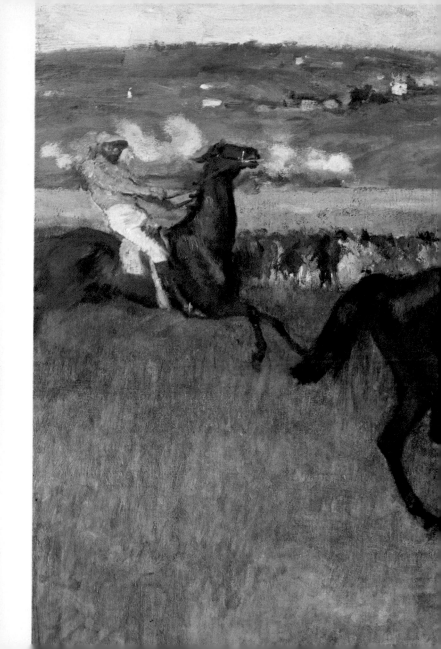

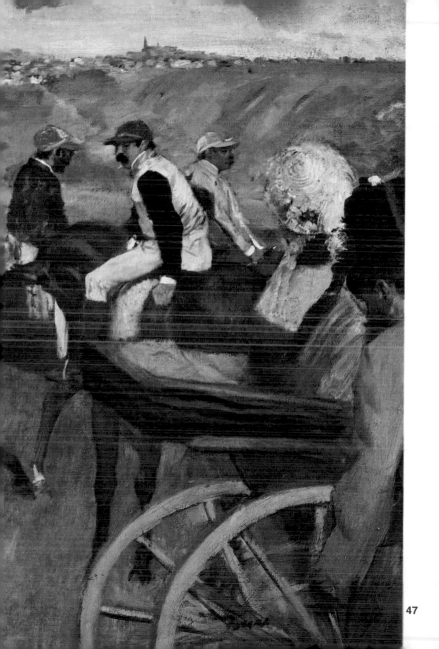

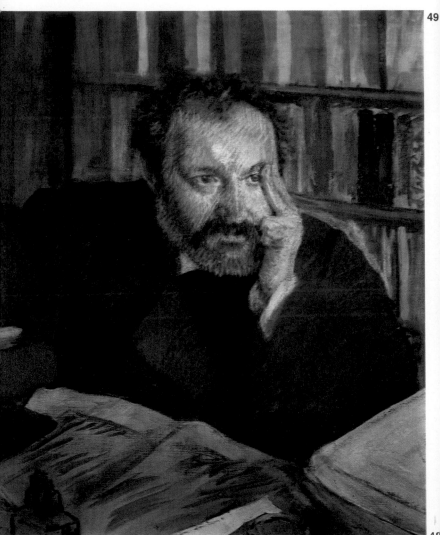

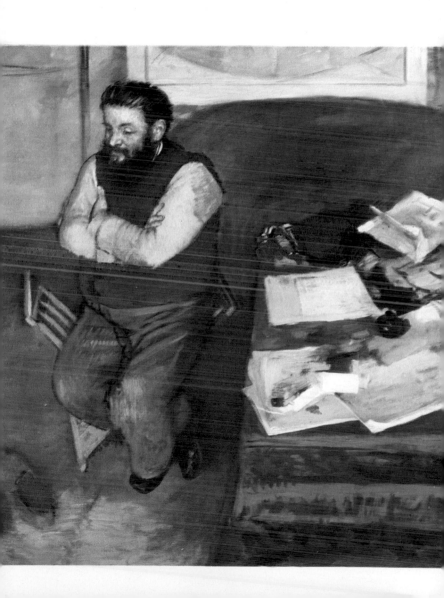

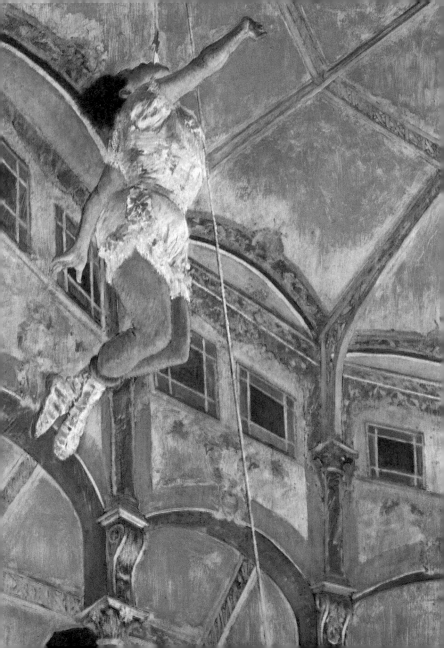

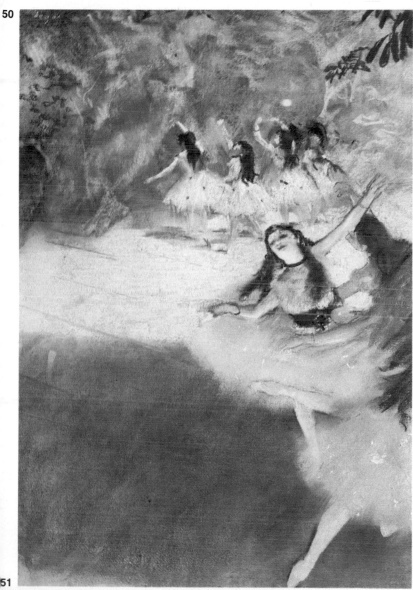

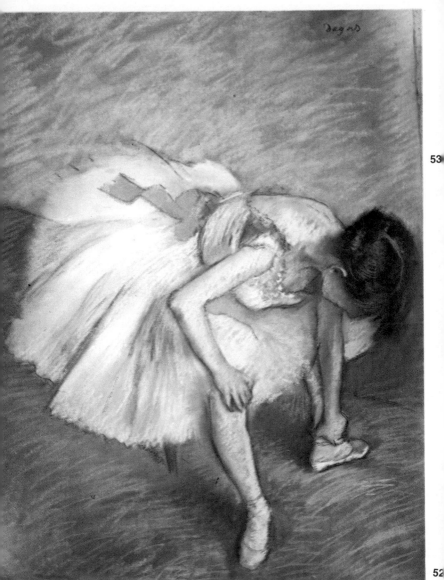

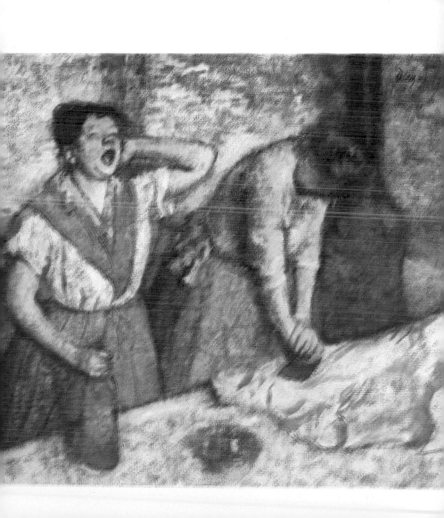

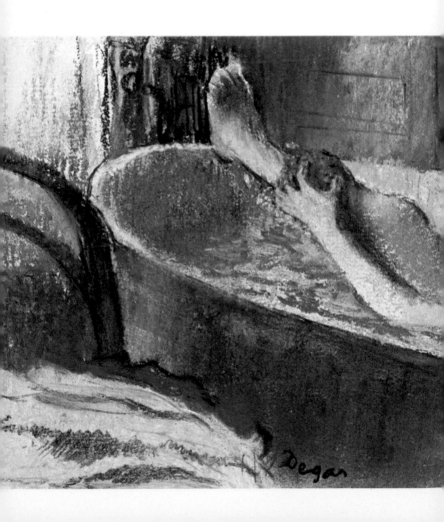

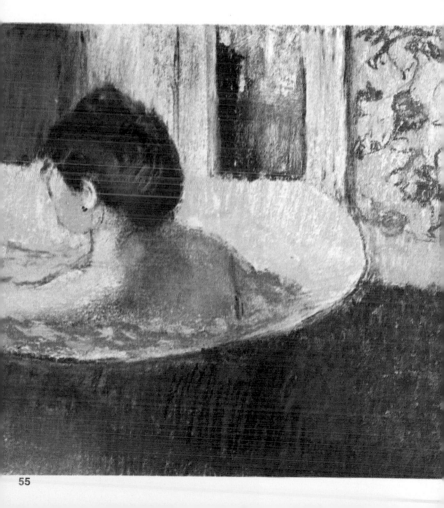

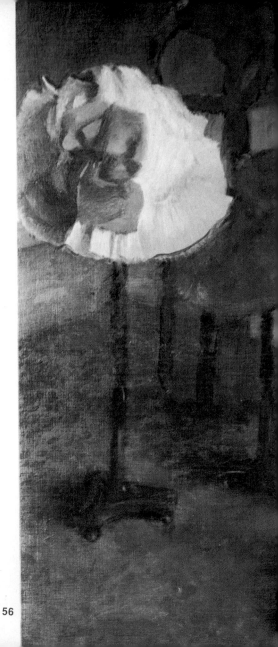

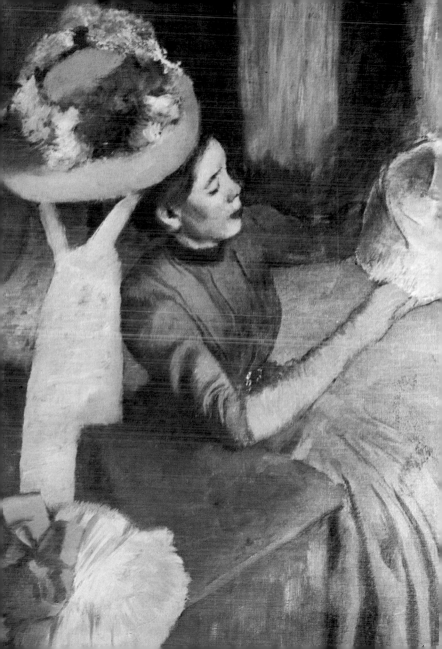

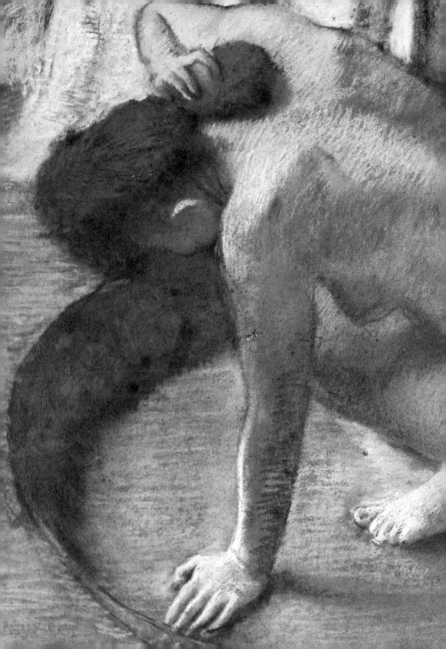

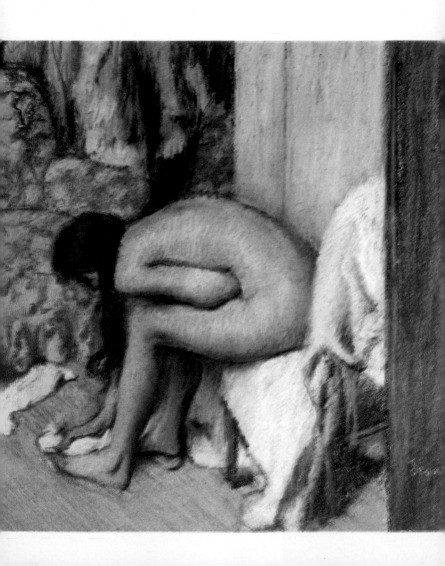

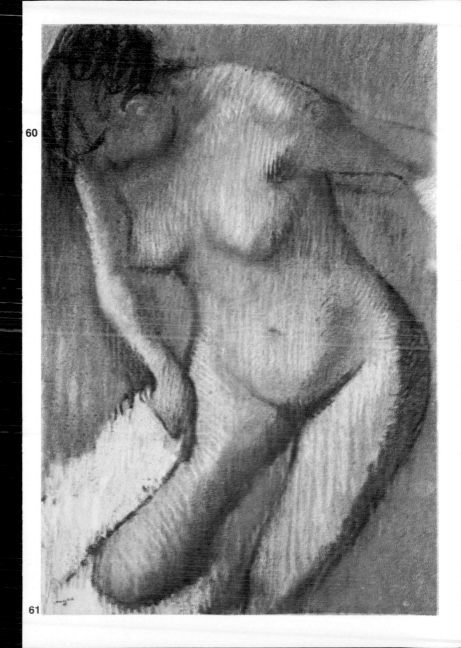

60

61

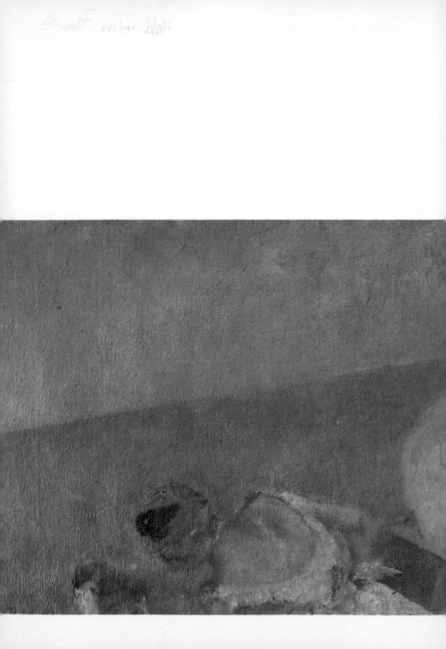

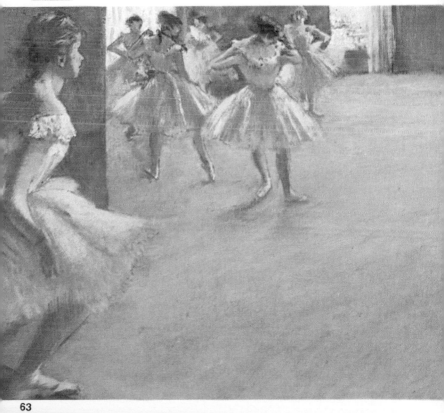

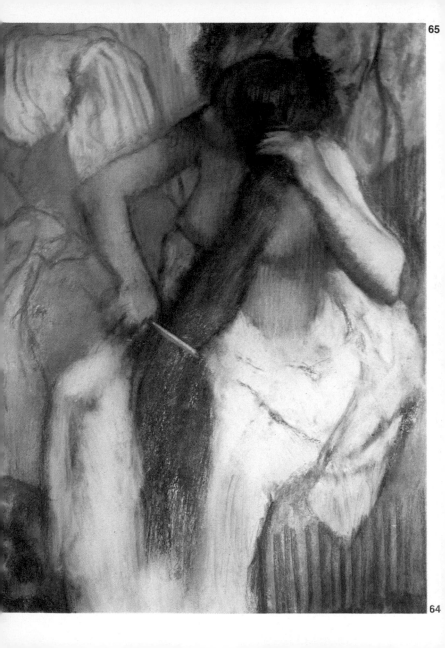

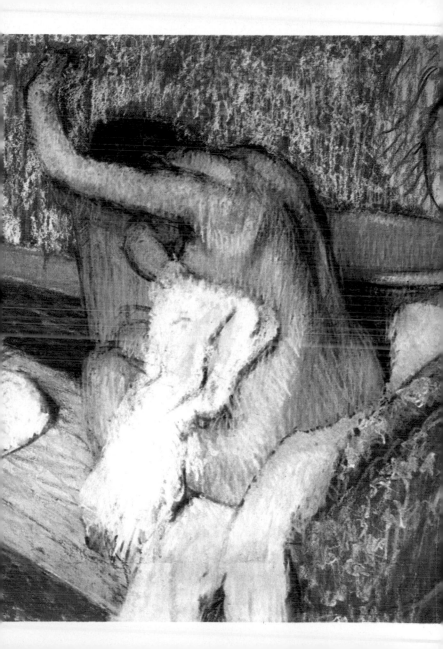

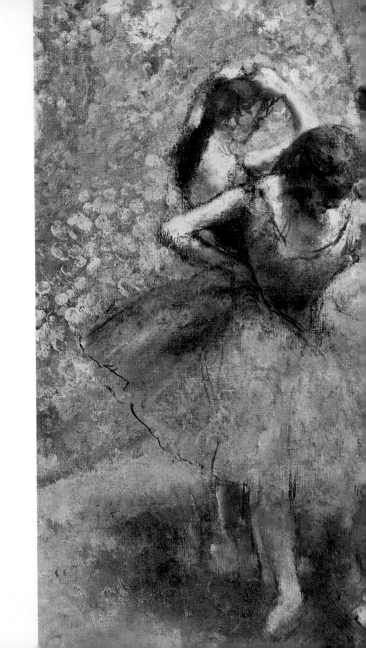

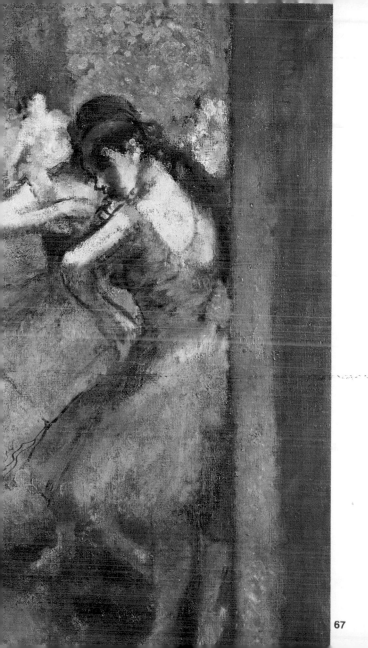

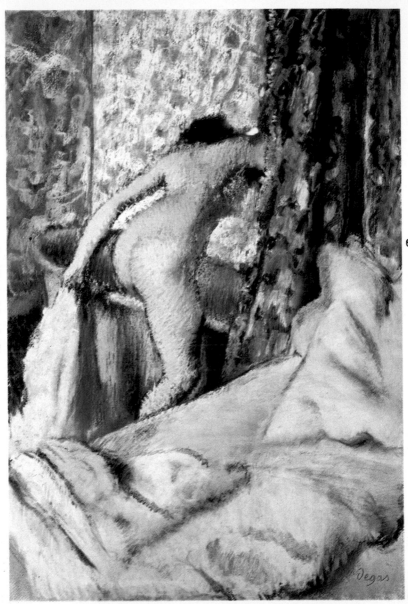

69

68 *Degas*

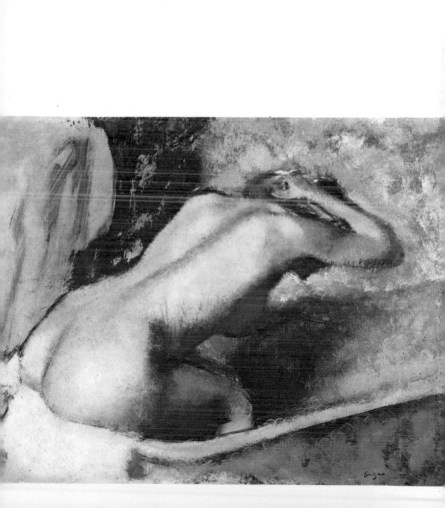

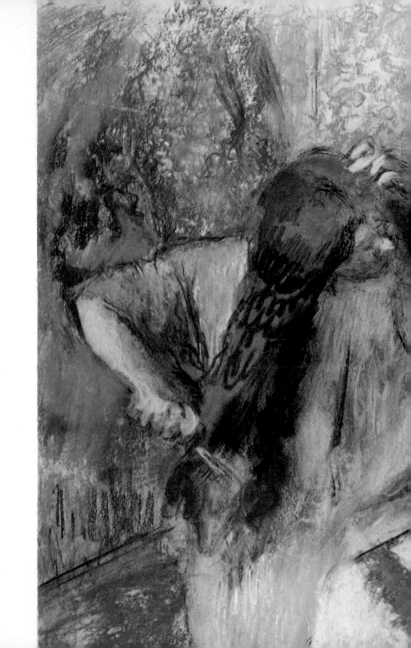

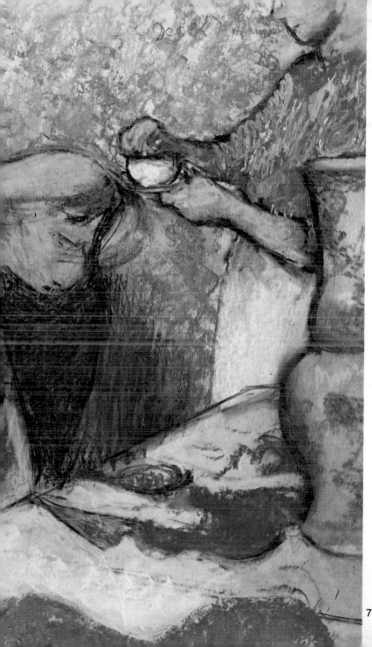

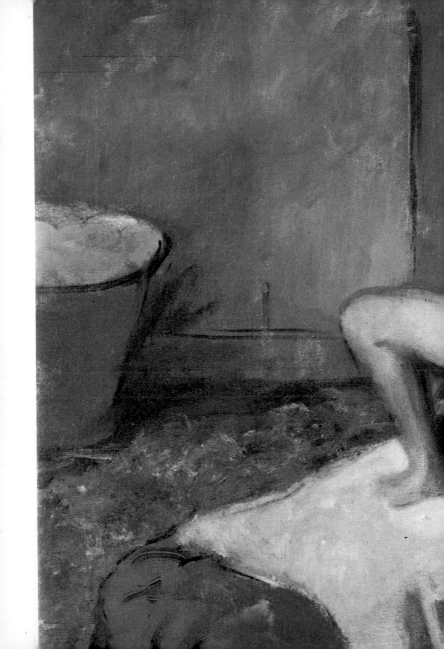

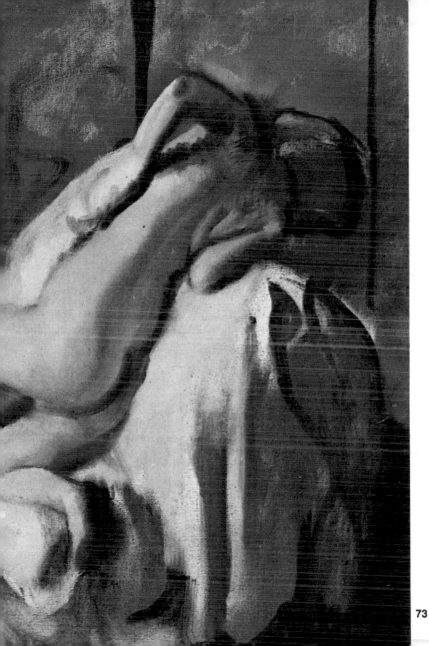

73

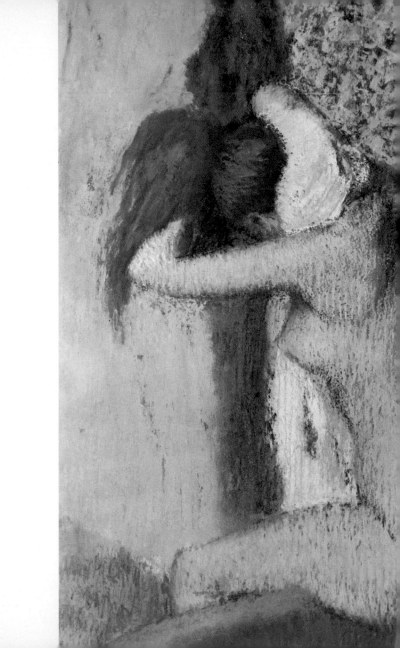

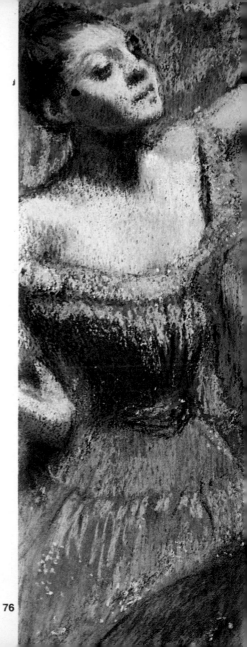

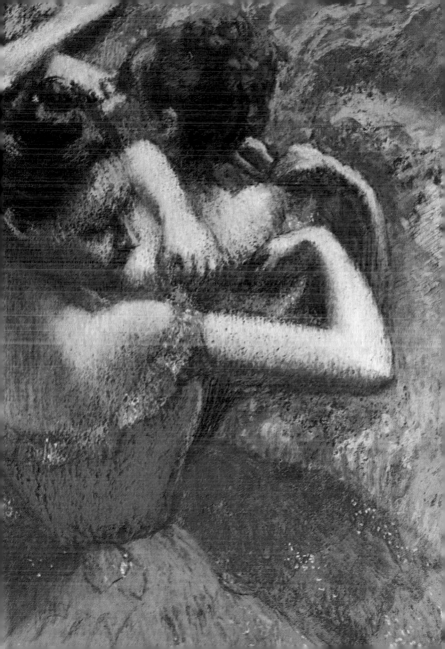